Keys to Painting
Light & Shadow

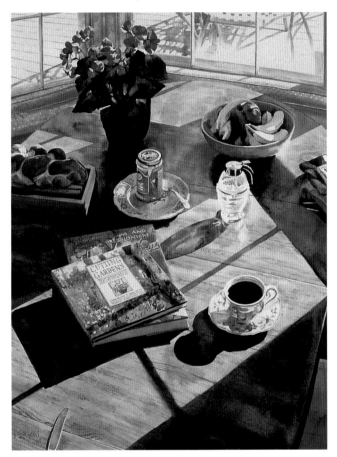

WILLIAM C. WRIGHT
"Coffee With Cutting Garden"
Watercolor, 21" × 16"
(53cm × 41cm)

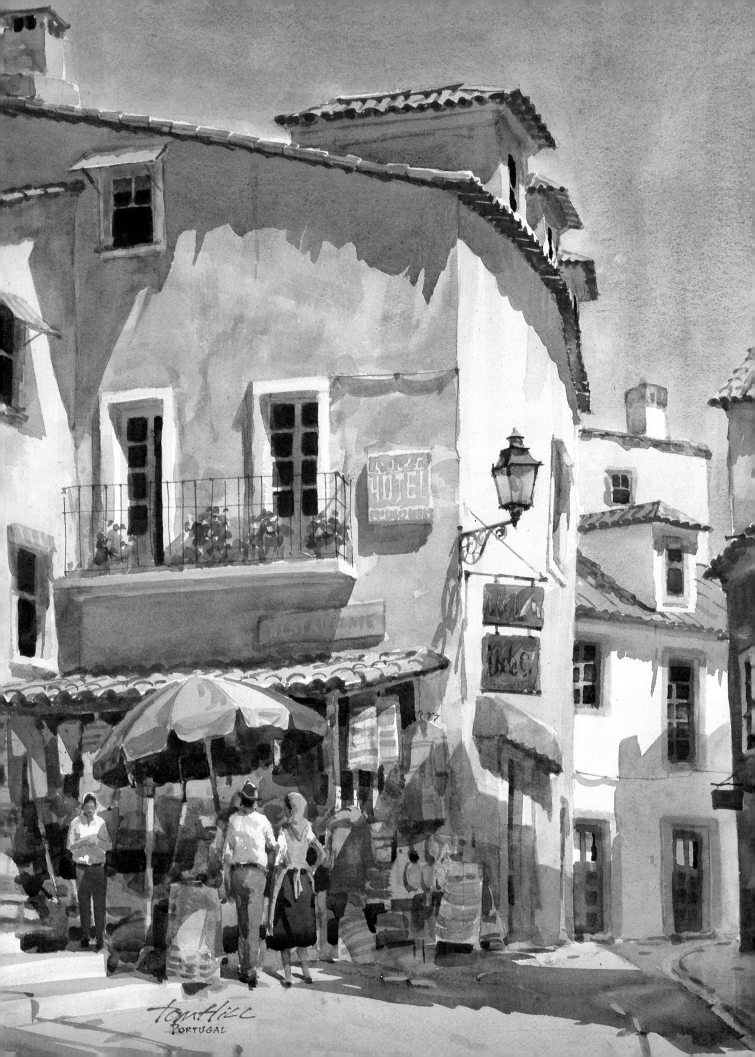

Keys to Painting
Light &
Shadow

EDITED BY RACHEL RUBIN WOLF

NORTH LIGHT BOOKS
CINCINNATI, OHIO

The following artwork originally appeared in previously published North Light Books (the initial page numbers given refer to pages in the original work; page numbers in parentheses refer to pages in this book).

Browning, Tom. *Timeless Techniques for Better Oil Paintings*; pp. 124-129; (pp. 70-75).

Donovan, Liz. *Painting Sunlit Still Lifes in Watercolor*; pp. 26-29, 72-74, 110-115; (pp. 52-55, 108-110, 98-103).

Hill, Tom. *The Watercolorist's Complete Guide to Color*; pp. 82, 85, 78-81, 84, 86; (opposite title, pp. 10, 12-15, 16, 17).

Kaiser, Richard. *Painting Outdoor Scenes in Watercolor*; pp. 58-63, 70-77; (pp. 18-23, 24-31).

Katchen, Carole. *Creative Painting with Pastel*; pp. 82, 84-85; (pp. 120, 118-119).

Lawrence, Skip. *Painting Light and Shadow in Watercolor*; pp. 4-11, 14-17, 52-59, 124-125; (pp. 78-85, 86-89, 90-97, 62-63).

Macpherson, Kevin. *Fill Your Oil Paintings with Light and Color*; pp. 42-47, 92-95, 108-115; (pp. 32-37, 38-41, 44-51).

Reynolds, Robert with Patrick Seslar. *Painting Nature's Peaceful Places*; pp. 109, 110-111; (acknowledgments, pp. 56-57).

Simandle, Marilyn with Lewis Barrett Lehrman. *Capturing Light in Watercolor*; pp. 69-75; (pp. 111-117).

Splash 4: The Splendor of Light; pp. 14-15, 26, 31, 34-35; (pp. 58-59, 76, 77, 60-61).

Strisik, Paul. Capturing Light in Oils; opposite title, pp. 124-127; (opposite table of contents, pp. 104-107).

Szabo, Zoltan. *Zoltan Szabo's 70 Favorite Watercolor Techniques*; pp. 86-87; (pp. 42-43). *Zoltan Szabo Watercolor Techniques*; pp. 14-18; (pp. 121-125).

Zemsky, Jessica. *Capturing the Magic of Children in Your Paintings*; pp. 72, 74-79; (pp. 8, 64-69).

Other fine North Light Books are available from your local bookstore, art supply store or direct from the publisher.

03 02 01 00 99 5 4 3 2 1

Library of Congress Cataloging-in-Publication Data

Keys to painting: light and shadow.—1st ed.
 p. cm.
 Edited by Rachel Rubin Wolf
 Includes index.
 ISBN 0-89134-931-6 (pbk.)
 1. Shades and shadows. 2. Painting—Technique. I. Wolf, Rachel.
ND1484.K48 1998
751.4—dc21 98-18847
 CIP

Content edited by Michael Berger
Production edited by Michelle Howry
Designed by Brian Roeth

ACKNOWLEDGMENTS

The people who deserve special thanks, and without whom this book would not have been possible, are the artists whose work appears in this book. They are:

Tom Browning
Roberta Carter Clark
Don Dernovich
Liz Donovan
Tom Hill
Richard Kaiser
Carole Katchen

Mary Lou King
Loren Kovich
Skip Lawrence
Lewis Barrett Lehrman
Kevin Macpherson
Robert Reynolds
Patrick Seslar

Marilyn Simandle
Sally Strand
Paul Strisik
Zoltan Szabo
Ben Watson III
Jessica Zemsky

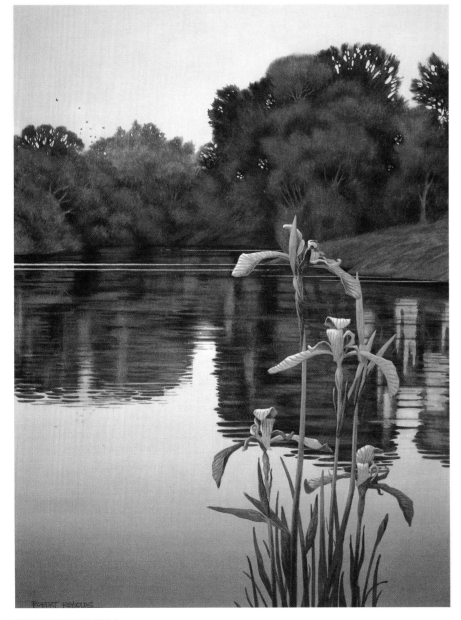

ROBERT REYNOLDS
"Symphony Suite: Interlude"
Watercolor, 35" × 24", (89cm × 61cm)

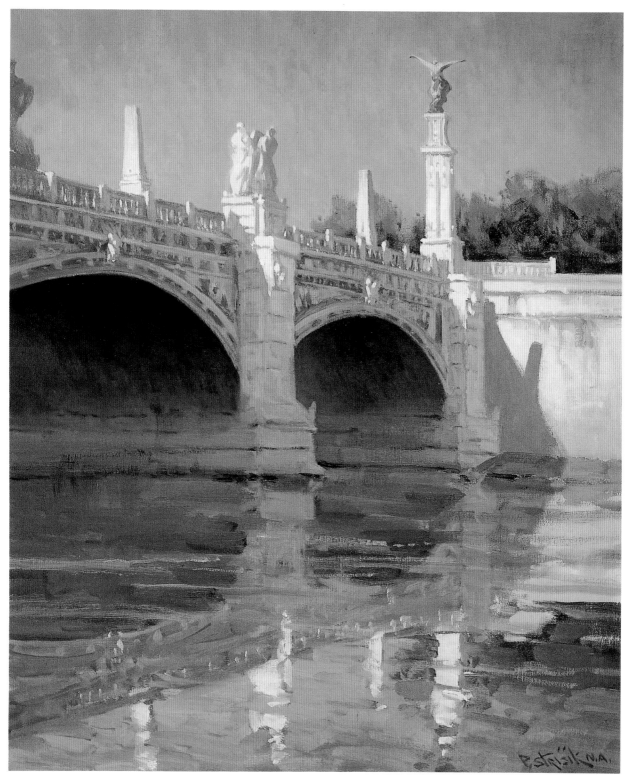

PAUL STRISIK
"Ponte Victor Emanuelle, III, Rome"
Oil, 24″×20″
(61cm×51cm)

TABLE OF CONTENTS

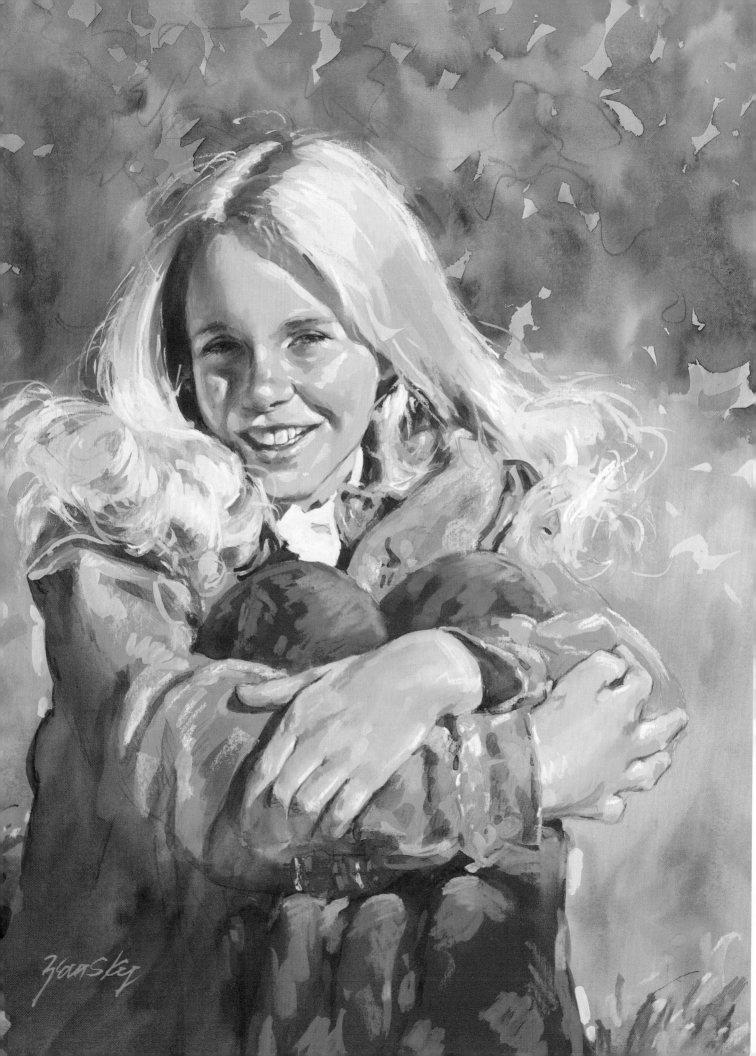

Light in all its forms may be the single most important tool available to an artist for expressing mood and drama in a painting. It has been used to symbolize knowledge, truth, goodness and spirituality. It is an enormous resource for an artist to utilize during the painting process. Light gives an object the shadows and highlights that describe its form. Light infuses your paintings with rich hues and casts shadows full of reflected color. Patterns of light and shadow are a great device for integrating the objects of your paintings into a pleasing design of light and dark values.

This book teaches you to see light and shadow. It teaches you to see as an artist. It teaches you procedures. And it helps build your confidence. You will learn how to understand light and shadow, and how their respective families work to define a painting. You will learn how to paint the sparkling effects of sunlight, and how to design effective compositions using light and shadow. And step-by-step demonstrations will help you understand how to approach light and shadow in any situation.

So no matter where you are on your personal artistic journey, this book is certain to provide new insights and new techniques that will help you discover the mysteries of light and shadow and, in the process, give you the keys to create better and stronger paintings.

JESSICA ZEMSKY
"Almost Grown"
Gouache, 24" × 20" (60cm × 50cm)
Collection of Mr. and Mrs. Bruce Lee

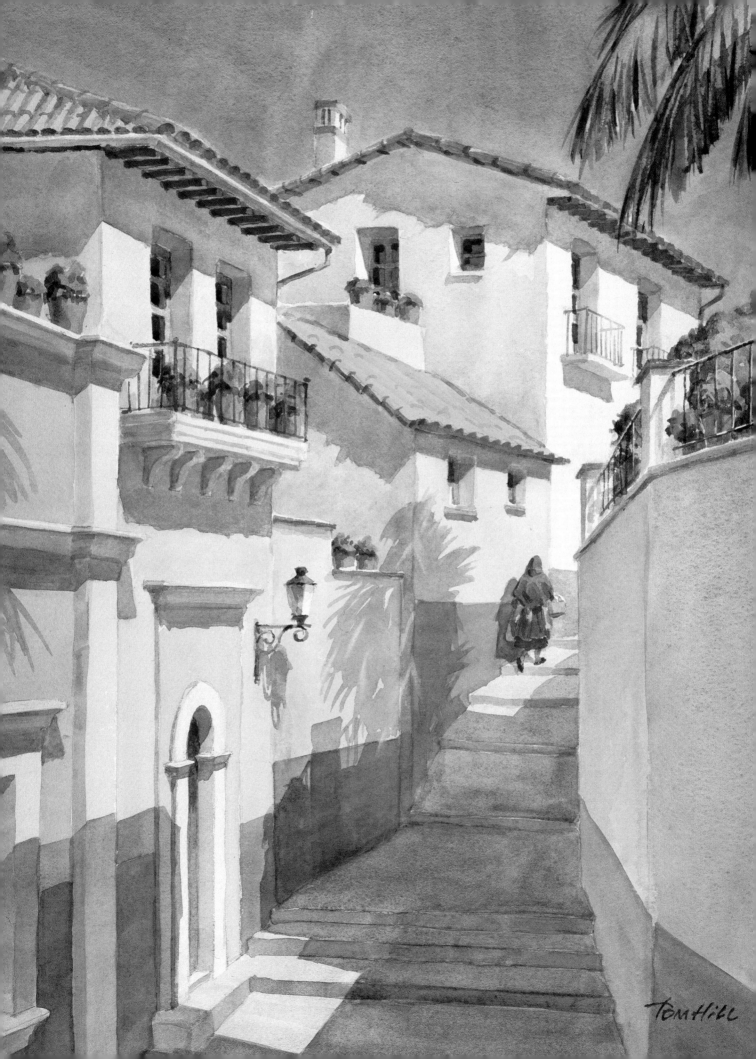

TomHill

Understanding Light and Shadow

Of all our senses, sight is our principal source of information. Light makes sight possible. Light, as it falls across the world around us, creates the colors and shadows that help to define the shapes, forms and textures we see. Over the next few pages, let's examine what happens when light falls across objects. By using basic shapes—in the form of boxes, cylinders, spheres and so forth—we'll explore how light, color and shadow all change as we alter both the direction of light and the surrounding environment.

SUNLIGHT'S ACTION

Since the sun is so much larger than the earth, the sun's rays can be considered parallel to each other. One of the easier ways to visualize the light rays of the sun is to think of them as streams of tiny rubber balls, unaffected by gravity, hurtling continuously in straight lines from the sun, and bouncing off whatever object they hit. The angle at which they hit determines the angle at which they bounce, and these angles are always equal. When the rays hit a flat surface at a right angle, they bounce directly back toward the light source, resulting in maximum light reflection. When they hit a flat surface at an oblique angle, they bounce off at an equally oblique angle in the opposite direction, resulting in less light reflection. The more oblique the angle, the less light is reflected from the surface.

Creation of Shadows

When light rays are interrupted by an object, that object gains light and shadow sides, and casts a shadow of itself. Those sides most directly facing the light are lightest in value; sides, or areas, more obliquely hit by the light are lower in value. Sides completely blocked from the light are in shadow and their edges will determine the shape of the cast shadow. On the next page, the box illustrates all this very well. So do the cylinder and sphere, which also have a gradation of shadow, as their curved surfaces gradually reflect less and less light, going into the shadow side.

Reflected Light

Of course, in most situations, there'll be other light rays—*reflected light rays*—bouncing off nearby surfaces and into the shadow sides of the object and into its cast shadow. These reflected lights can be anywhere from obvious to very subtle, and will reflect the colors of the objects from which they are bouncing.

Suppose you're painting a subject that's part in sunlight, part in shadow. The subject's color in sunlight isn't too difficult to determine, but how do you paint the change that happens to that color when it's in shadow? The photos on page 15 should help in understanding the way colors change from sunlight to shadow.

TOM HILL
"Morning, Old Town, Granada"
Watercolor, 17" × 13" (43cm × 33cm)

Anatomy of Shadows

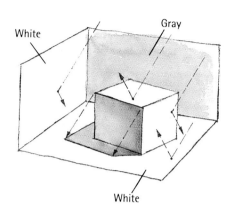

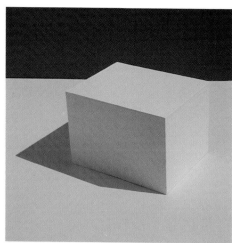

In the photo, the white box is in a "color neutral" setting: white or gray surroundings. In the illustration, the dashed-line arrows represent the sun's parallel light rays: how they bounce at equal angles and how they define the box's shadow. Notice that in the photo the cast shadow is darker than the shadow side of the box. Also notice how the shadow on the box seems a bit darker just where its edges meet the lighted sides.

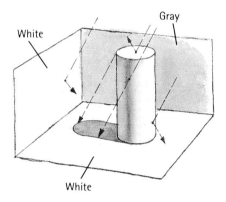

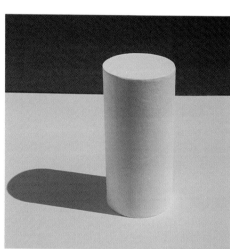

Here's the same neutral setting, which, in the photo, enables us to see just the value aspects of color. See how the light rays are gradually cut off by the curved shape of the cylinder, and where they can no longer strike we see a darker vertical area called a shadow "core." After that, the shadow gets lighter again, due to reflected light coming from the left.

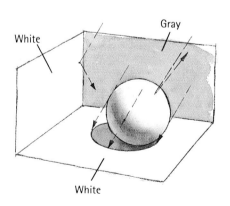

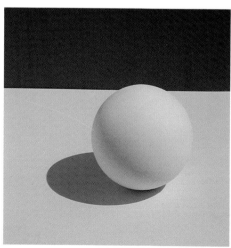

Again, here we have a "color-neutral" setting. The sphere has a shadow "core," too, but because the sphere is continuously curving in all directions, its shadow core is crescent shaped, diminishing toward each end. Notice that in the photo the cast shadow is darker than the shadow on the sphere itself, and especially dark directly under the sphere.

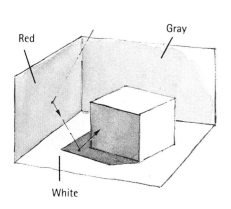

Red / Gray / White

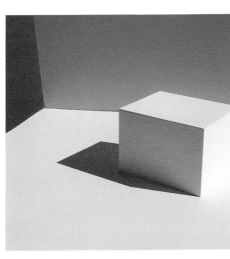

Here's the same white box, tabletop and gray background, but now there's a red wall to the left. In the photo you can see red light reflected into the shadows, tingeing them with a pink hue. Even the tabletop and the gray background are influenced toward red. The illustration helps explain the light's action in a more graphic way.

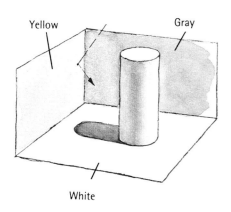

Yellow / Gray / White

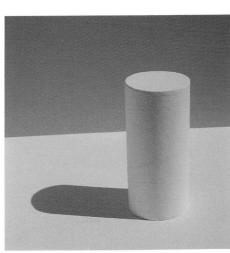

Now, the same setup as above but with a yellow wall to the left of the cylinder. Reflected yellow light now permeates the whole scene, even tingeing the dark cast shadow with a hint of yellow. Try imagining that the cylinder is a silo and the yellow wall a yellow house. You can quickly see the importance of color in reflective light and its application to your painting problems!

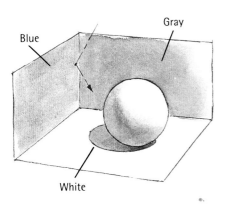

Blue / Gray / White

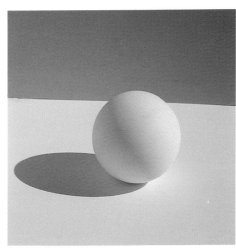

The sphere in this photo is under the influence of the blue to its left, but this blue is a little less intense than the red and yellow shown above. Its effect is more subtle, though just as invasive. You could compare it to the blue "sky light" seen in nature, where the light from a blue sky reflects onto shadow sides of objects in a landscape setting.

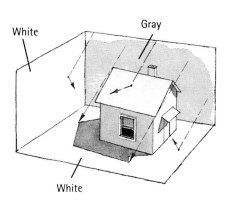

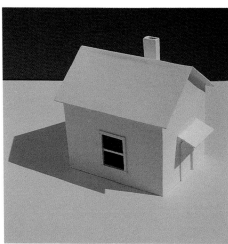

Light falling on this white house in a "color-neutral" setting behaves exactly the same as it did on the white box—but there are more complexities to look for. The slanting roof reflects less light than the box's flat top; the more complex shape of the house casts a more complex (though logical) shadow. The illustration accentuates what happens.

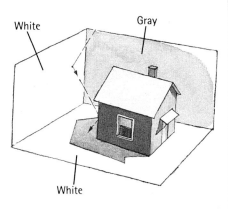

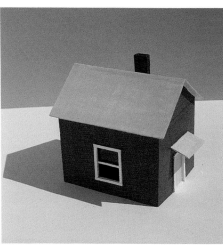

In this photo, you can see that the cast shadow is no longer darker than the shadow on the house, because the house's walls are now red—a darker value than white. The illustration shows how light rays do a double reflection, bouncing off the white wall to the left, then off the red wall at the back of the house and tingeing the cast shadow pink!

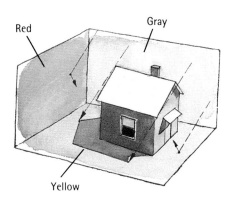

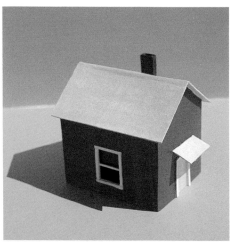

Now, a colored house in a colored setting, diagrammed by the illustration. Red from the left is reflected into the yellow "ground," turning the house's cast shadow orange. The same yellow reflects up into the shadow on the house itself, turning the red warmer and brighter. Even the neutral gray background is tinged by red (left) and yellow (right) in the photo.

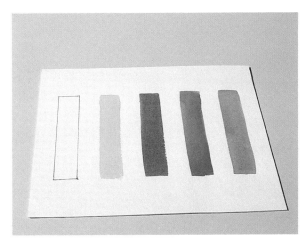

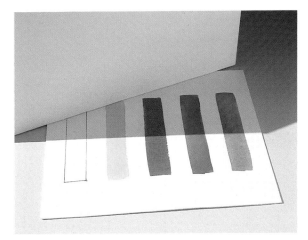

A color in sunlight looks different than it does when it's in shadow. Although pigments aren't perfect and really can't exactly duplicate light, here's an experiment to help you learn how to come fairly close to mixing and matching the colors you see in shadows. The photo above shows five 2″ × 6″ (5cm × 15cm) swatches in full sunlight. The white one is the paper itself, the others are New Gamboge Yellow, Scarlet Lake, Ultramarine and Thalo Green, but they could be any colors you choose. Just think of them as colors on some object that's in a painting you're making.

Here, a shadow has been cast over part of each color swatch—just as shadows might happen in a real painting situation. You can see how the colors in the shadow have changed: They're less intense in hue, darker in value, and any reflected light or color that's nearby will now be more apparent in shadow than it would be in direct sunlight. Assuming that it's fairly easy to paint the color that you see on the sunlit side, how would you mix your paint to duplicate the color you see on the shadow side?

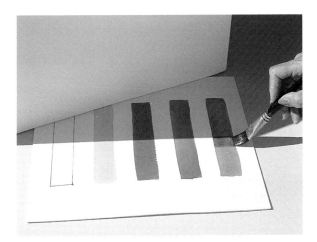

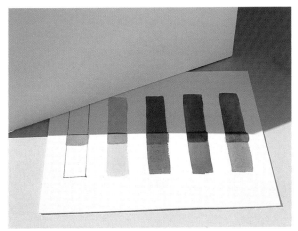

This photo shows Thalo Green's shadow color being matched with a glaze of paint over the Thalo Green color that's in the sunlight. Here's how it was done: To some additional Thalo Green on the palette, a little bit of Thalo Green's complement, red, was added (in this case, a dab of Scarlet Lake). Now the wash was less intense and darker in value. Because of the blue light that was being reflected in from a blue sky above, a tiny bit of Cobalt Blue was added. When this mix was painted next to the shadow color, as you can see, a good paint-color to actual-color match was achieved.

The same thinking was used to produce close color matches for the other colors: more of the original color, a little of its complement, then adding whatever reflected light color might be affecting the color in the shadow. To duplicate white's shadow color, a correct value of neutral gray was mixed and a little blue added to account for the reflected blue light from the sky. Try this approach with any paint color. Some variation and modification may be needed to account for the individualities of different pigments, but you can always check your results for veracity by comparing them with the actual colors in sunlight and shadow.

Color in Shadows

MORNING LIGHT

When light bounces and rebounces from one surface to another, it carries reflected light and color into shadows. Here are two nearly identical paintings by Tom Hill. One demonstrates what happens to light and color in the shadows that are cast by an object; the second shows what can happen to the light and color in the shadows that are on the object itself.

The cast shadow here gets less direct light than the front of the building, but picks up more cool from the sky.

The warm bounce light here gets little chance to catch any blue from the sky.

The cast shadows from the palms pick up warms from the opposite wall but also cool colors from the sky, where the wall turns the corner.

This wall is getting a little less direct sunlight than the front of the building, so it is slightly lower in value and has both warm and cool influences in it.

The cast shadow on the wall has cool from the sky at its lower edge, and warm from the tile roof below on its upper part.

Sunlight's direction

Warm light reflects up from the roof and earth below.

This part of the wall is catching warm bounce light from the building at the left.

This part of the wall is angled differently and is cooled by sky influence.

The warm light bounces twice: first off the building to the wall at right, then back into the cast shadow on the building.

The cast shadow is warmed in parts by building reflections, cooled in other parts by the sky above.

TOM HILL *"Morning, Old Town, Granada" Watercolor, 17"×13" (43cm×33cm)*

In this scene the sun is about halfway above us, over our right shoulder, and a bit in back of us. (Notice the arrow in the diagram above, indicating the light source.) The emphasis here is on showing what cast shadows do, especially regarding what happens to color.

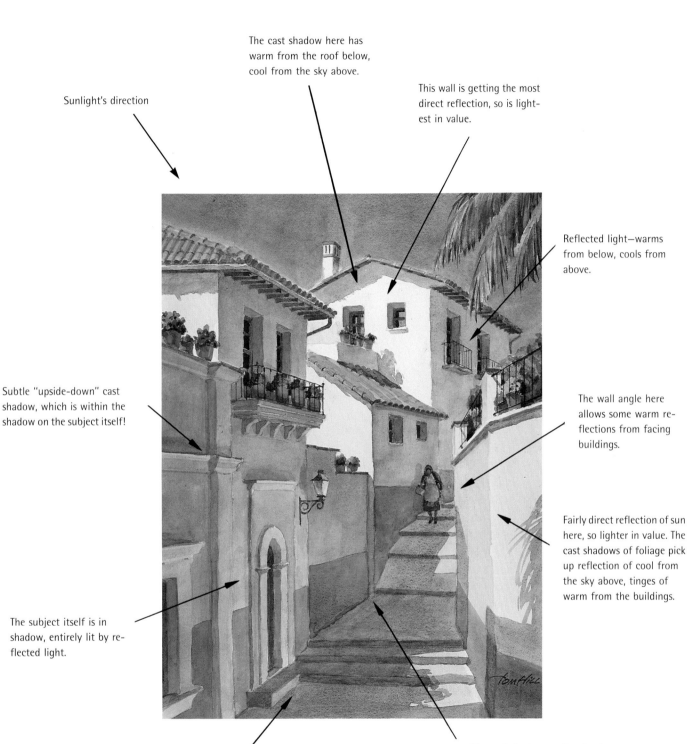

The cast shadow here has warm from the roof below, cool from the sky above.

This wall is getting the most direct reflection, so is lightest in value.

Sunlight's direction

Reflected light—warms from below, cools from above.

Subtle "upside-down" cast shadow, which is within the shadow on the subject itself!

The wall angle here allows some warm reflections from facing buildings.

The subject itself is in shadow, entirely lit by reflected light.

Fairly direct reflection of sun here, so lighter in value. The cast shadows of foliage pick up reflection of cool from the sky above, tinges of warm from the buildings.

The cast shadow on the street here is more under influence of cool from the sky above.

The cast shadow on the street here has some reflection of red from the building at the left.

TOM HILL *"Afternoon, Old Town, Granada" Watercolor, 17" × 13" (43cm × 33cm)*

Here's the same scene as on the preceding page, but this time the sun has been moved to a position halfway over our left shoulder, again a little in back of us. Now the emphasis is on examining what happens to color in the shadows that are on the subject.

Top Light

On a clear day at noon, sunlight tends to be yellow-white. This is the brightest part of the day, and the sun, being directly overhead, forces a sharp downward contrast on anything it shines upon. It also throws lots of reflected color into the shadowed areas. This reflected light will show the color of whatever is next to the shadow. Though top light is quite different from sunlight that falls at other angles, you can sometimes get some great paintings when the sun is directly overhead.

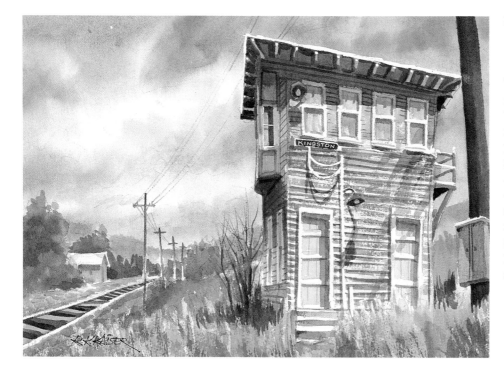

RICHARD K. KAISER
"Kingston Railroad Tower"
Watercolor, 10" × 14" (25cm × 35cm)

This interesting railroad tower of a bygone era is made of a lot of weather-beaten boards. The top lighting, with its tendency to show lots of detail, emphasizes the "beaten" quality, revealing how old this building is. Top light also usually minimizes overall value contrasts. Note that the painting is basically in a mid-value range. For this reason it can be difficult to create an interesting composition under top lighting conditions. But that's no reason to avoid it.

RICHARD K. KAISER
"House, Stonington, Connecticut"
Watercolor, 10" × 14" (25cm × 35cm)

One of the best effects of top lighting is that it can force you to add color to your shadows. In this painting, note how the dark areas still say shadows but contain a lot of warm reflected light. Going from light to dark and from dark to light helps to solidify the scene. Leaving some of the grass white also suggests the bright overhead sunlight.

Put a cast reflection of the roof stays in the window on the right, plus a little vertical cast shadow of darker Cerulean Blue. Leave a lot of white in the clapboards and accentuate the cast shadows underneath. Leave as much white as possible to show direct light on a subject.

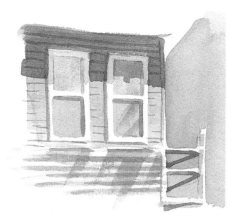

This detail of the roof of the railroad tower shows the cast shadow. Lay down a light glaze of Yellow Ochre into the eaves under the roof to help punch up the reflected light.

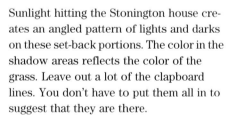

Most of the side of the building is in shadow from the overhang on the tower, so gradate it to keep it from being flat. There are a lot of different colors in the shadow area of the grass. In nature, objects also pick up color from reflected light. Incorporate more colors to enhance grass and foliage.

Sunlight hitting the Stonington house creates an angled pattern of lights and darks on these set-back portions. The color in the shadow areas reflects the color of the grass. Leave out a lot of the clapboard lines. You don't have to put them all in to suggest that they are there.

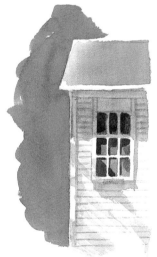

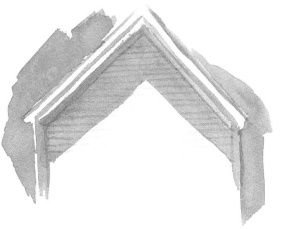

The steeply angled gable creates an angled cast shadow on the white clapboards. The subtle yellow tones add warmth to the cast shadow.

Gradate the green on the roof from light to dark, and save the whites along the edges. The colorful cast shadows on the side of the house help to establish form, create interest and indicate the direction of the sunlight.

Backlight

When the sun faces toward you, it tends to make silhouettes of everything, creating strong value contrasts and minimizing color. Shapes predominate, and you have to punch up your color to avoid making them all black. Objects facing the sun will mirror it. Their angle will determine how much light they reflect. Observe the smaller objects' light, but don't let them take over the scene. The main point of interest, often silhouetted against a bright sky, should stand out.

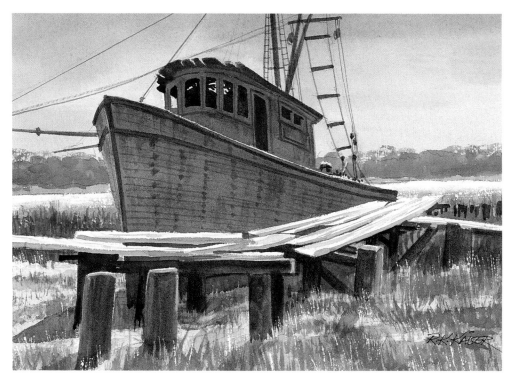

RICHARD K. KAISER
"Shrimp Boat, Hilton Head Island, South Carolina"
Watercolor, 10" × 14" (25cm × 35cm)

On this hot day the bright sunlight was coming right at the artist, Richard Kaiser. The bright light made the planking appear white and raised a hard white light along the edge of the boat in front of the cabin. Some of the grass showed white as it sparkled with the sun on it. Kaiser purposefully filled the dark silhouette shape of the boat with lots of reflected color, though at times it appeared almost black. Backlighting conditions create a visual strain but can produce very dramatic compositions.

RICHARD K. KAISER
"Mendocino, California"
Watercolor, 10" × 14" (25cm × 35cm)

The coastal town of Mendocino has many great sights, and has been quite an artists' colony for many years. This painting shows a different use of backlighting. Instead of silhouetting a large central shape, the backlight here has made a frame out of the objects in shadow—the trunk, leaves and house's entrance. This helps us feel as if we are part of the scene and makes the distant view more interesting.

Do all the work on the sky and background before painting in your backlighted object. For the sky area behind the boat, paint a wash of Ultramarine Blue, and while it is wet, touch it with Yellow Ochre, then put it behind at the skyline. When it dries, lay in a light wash of light yellow-green for the far-away trees.

Keep the boards quite white (with just a little gray to show form and texture) against the dark of the boat and grass to show how bright the light is. Notice the dry-brush effect of Cerulean Blue for the water. If your initial brushwork doesn't go down perfectly, you can take a razor blade and scratch it over the blue to give the effect of sparkling water.

Keep the edges of the piling quite light to show the sunlight hitting the other side. Even in bright sunlight, there will sometimes be a cool color thrown on a shadowed side, so add a touch of Cerulean Blue to one side to cool down the post.

To show a warm, glowing background of hazy sunlight, put down a wash of Yellow Ochre and lightly flow another wash of Payne's Gray into it, adding a slight touch of Ultramarine Blue to some outer parts. The light washes of the coastal lands are made up of Ultramarine Blue and Burnt Sienna. One headland is lighter than the other, as it's farther away. Lift a couple of white lines out of the water wash to show surf near the base of the headlands. Keep the washes of trees and buildings light, as they are farther away from your foreground subjects and are bathed in sunlight.

To show reflected sunlight, add a lot of warm Yellow Ochre in the white shadowed sides of the buildings and save a lot of whites on the trees and roof edges.

Side Light

When sunlight strikes an object from either the left or right, the shadows cast emphasize the object's form. They also make patterns that can be used by the artist to direct the viewer's eye to the center of interest. The shadows created when side light hits a form tell the viewer whether that form is square, round, triangular or some other shape. Because of the effects of side light, early morning and late afternoon have long been favorite times for a great many artists to paint.

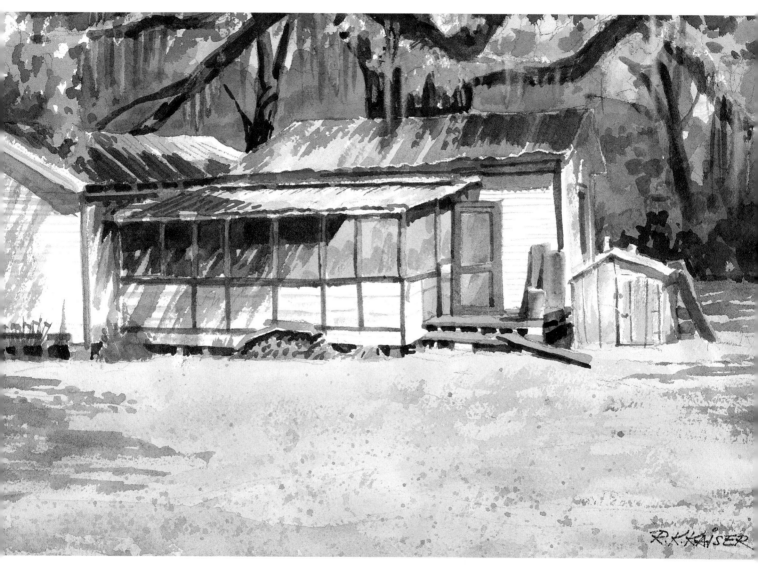

RICHARD K. KAISER
"House on Defusky Island, North Carolina"
Watercolor, 10"×14" (25cm×35cm)

This small island off the coast of North Carolina can only be reached by boat. Until a few years ago, only fishermen and their families lived on it, and it was quite rustic. The house itself has tremendous textures and angles to it—a good subject for side lighting. In particular, the texture of the corrugated tin roof is revealed by the light coming from the right. In this case, the shadows from the sun are complicated by the cast shadows from the tree.

The interplay of sunlight and shadows shows the texture of the roofs. Leave as much white as you can to show the sparkle of sunlight and the angle of it from the right. Leave some holes in the shadows because trees are not solid. Their leafy foliage allows spots of sunlight through to even heavily shaded areas.

Tin roofs are always fun to paint. Their corrugated tops make all shadows hitting them interesting. Note the shadow's edges on the top and the shape of the cast shadow on the side of the building. If you weren't sure the roof was corrugated, the shadows would sure tell you.

Keep the little shed simple, and leave white whenever you can. The can on top adds a funny touch, and the red piece of sheeting makes a nice contrast (cool vs. warm), throwing red into the shadow it casts. The light from the right defines the planes very clearly.

Twilight

Painting by the light of the setting sun is enjoyable and has produced many award-winning scenes. Yes, there are special problems that arise at these times, but by planning ahead and working quickly, you can conquer them. If you are painting outdoors, the light changes more rapidly at this time of day than at any other. (Here's where a camera will come in handy.) Scenes painted during twilight are usually low-key (on the dark side). Showing a warm glow in the sky with crimson, magenta and violet colors is one way to get the effect of twilight. Houses can be silhouetted against the sky, and you can put lights on in the windows. To show lights on in a house, or reflected light in puddles, or even highlights of rooftops, first mask out these areas, then paint around or over them. Keeping whites on your paper is important, even for a scene painted in twilight.

RICHARD K. KAISER
"Berkshire Farm, Massachusetts" Watercolor, 10″×14″ (25cm×35cm)

Massachusetts is a lovely area in which to paint, dotted with quaint little towns plus beautiful mountains. You can capture the softness of the scene by using low-key colors on the cool side. Twilight paintings are a special kind of backlight painting. Often the sky remains colorful and bright, while the darker objects of the landscape stand silhouetted against it.

RICHARD K. KAISER
"New Hampshire Farm"
Watercolor, 10″×14″
(25cm×35cm)

This painting captures the quiet of early evening. The sun is just going down, the chores are done, and the farmer and his family are having dinner. A lot of reflected sky light is on the roofs and sides of buildings and the grass, but the bulk of the painting is in a low (darker) key. The lightest areas are the sky and the windows.

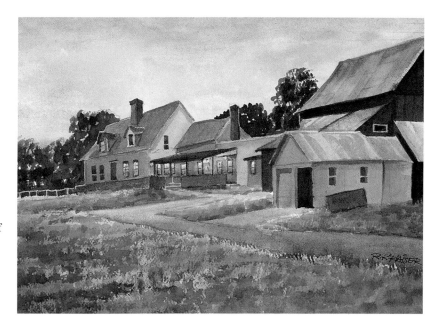

To paint a twilight sky, first wet the whole sky area with clear water. Then start at the horizon and work upward with a light wash of Alizarin Crimson. Add Cadmium Orange, then Cadmium Yellow, then Cerulean Blue, Mauve, and then on to Ultramarine Blue, and finally a darker mixture of Ultramarine Blue. To help the blending, tilt your paper upside down so all of the washes head toward the Ultramarine Blue.

Keep the roofs light against the darker Burnt Umber of the trees. The Cerulean Blue wash reflects the sky and makes it the lightest spot in the darkened scene, except for the lit windows. Light from the windows lightens the grass below the windows.

Trees painted at twilight should be quite dark to stand out against the sky, but lighten the side of the trunk that faces the setting sun. Indicate branches heading toward the sun with lighter washes of Burnt Umber.

The big barn roof should be dark enough to silhouette it against the sky, but light enough to reflect the waning light and to contrast with the darker vertical walls.

Night

Nothing can be more dramatic and unique than night scenes. But they can also be tricky to paint because there are usually several different light sources. This difficulty will be multiplied when the lights reflect off rooftops, sides of buildings, windows and rainy street puddles. For a night scene, plan to do a value sketch. Your careful study will pay off. Even in a low-key painting, you'll need to save your whites. Probably the best way to start your painting is with a medium or middle-dark tone. In the daytime you usually work from light to dark, with one light source. But in a night scene you have many different light sources to contend with. Make sure that you leave a lot of light around the light source and subdue the rest of the painting. The warm yellow-white of incandescent lights and the cool blues and violets of the night sky provide the dramatic contrast that make night scenes so intriguing.

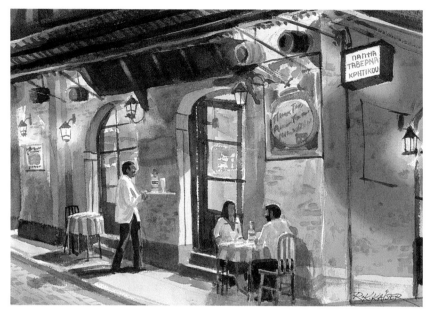

RICHARD K. KAISER
"Kritikos's Tavern, Greece"
Watercolor, 10" × 14"
(25cm × 35cm)

Check the angles of light hitting objects and casting shadows. Often shadows will go in multiple directions in night scenes. Also note the golden halo around each lamp—and how the light drops rapidly to dark as you move away from the light source.

RICHARD K. KAISER
"Le Consulat, Montmartre, Paris, France"
Watercolor, 10" × 14"
(25cm × 35cm)

Montmartre is home to many artists and writers. The hustle and bustle of the day here continues into the night. Areas like this are well lit, and there seems to be a dividing line of value change between the street level and the darker area above. Notice how the eaves of the buildings are bottom lit with warm lighting coming from below.

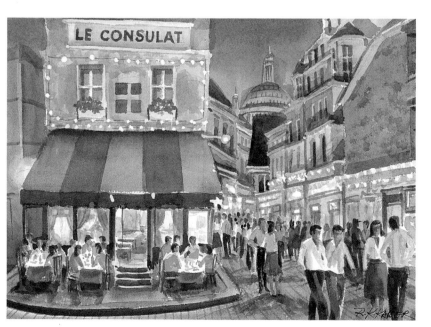

To make a halo of glowing light, start with a circle of clear water over the light to about a 1-inch (2.5cm) radius from it. Next add a wash of Phthalo Blue darkened with a light touch of Alizarin Crimson. Float the darkened wash all around the clear water areas, just touching it. The dark blue tone will diffuse immediately and cause a halo effect. Absorb a little of the blue with a clean wet brush if it invades too much into the clear white area. After this is dry, lightly brush a soft wash of Cadmium Yellow over the clear white halo that was left. Keep the center of the lamp pure white to make it look quite bright. Add the black fixture last.

Leave the top of the woman's head, her shoulders and parts of her arms pure white to indicate the direction of light from the tavern's doorway. Reflected light from the tablecloth lights up her face.

The waiter and the front of his jacket strongly reflect the white light from the doorway, while the back of the jacket reflects the soft yellow glow of the lamps.

To paint well-lit buildings at night, leave the railings or eaves pure white. Paint a warm blue-gray wash over all the fronts and sides of the buildings. When this is dry, add the dark shadows coming up from the street over parts of the fronts of the buildings. Keep the shadow narrow near the street, and as the building gets higher, make the shadows higher and deeper. When the shadow washes are dry, go back and add your windows. Then add a light yellow wash to the white fronting eaves or railings. A very light wash of the same yellow on the fronts of the buildings indicates reflected light from the street.

Reflected Light

Light does two things: It illuminates your subject and it reflects off the subject. Wherever there are shadows made by sunlight, there will be reflected color from the surface right next to the shadow. This is very apparent in a street or alley scene. Sunlight hits a building on one side of the street and leaves the building on the other side in shadow. The local color of the building hit by the sunlight will be thrown into the shadows of the other building. On a sunny day, go out and observe this phenomenon. Some painters always make the shadows in their paintings gray, black or blue. When you look at these paintings, you may think, "There's something wrong. They don't look quite real." You're right. Your "inner eye" is telling you that the scene lacks authenticity or truthfulness in its representation. Study, observe, look, and look again. The color is there. You just have to be more aware of it. When you start to add color to your reflected light, you will see your paintings spring to life.

RICHARD K. KAISER
"Street in Patzquaro, Mexico"
Watercolor, 15" × 22" (38cm × 55cm)

Patzquaro, Mexico, is a town situated about seven thousand feet up in the mountains of central Mexico. This typical street scene, amidst the white stuccoed buildings of the town, gives you the feeling of a hot day. See how much warmth is reflected into the shadows from the color all around?

RICHARD K. KAISER
"Purity Springs House, New Hampshire" Watercolor,
10" × 14" (25cm × 35cm)

This little, old house nestled in the pine area of Purity Springs offered a wonderful opportunity to practice painting reflected light. White surfaces, in fact, probably show the most colorful reflected light. Notice both how many colors are used in the shadows and how strong they are without appearing out of place. Look at the color of the porch ceiling.

For the shadow area over the balcony, quickly float in a wash of Ultramarine Blue and Burnt Sienna. While it is still wet, float into it Yellow Ochre and Alizarin Crimson to add warmth to the shadow area. The pure white edge along the balcony shows that the top of it is bathed in hot sunlight. The Cadmium Orange stroke under the balcony and the underside of the doorway also indicates the reflection of bright sunlight from the street below.

For someone standing in a brightly sunlit street and peering into an open doorway, the interior will appear, by contrast, very dark. But look again—reflected light from the street illuminates not only the doorway, but objects just inside, too. Here, after you lay down Burnt Sienna for the shelves, float a wash of Ultramarine Blue and Alizarin Crimson over the top half of the shelves to push them back into the darkness of the doorway.

The cast shadow under the roof eave is made of Ultramarine Blue and Burnt Sienna. While it is still wet, float in Yellow Ochre and a little Alizarin Crimson to suggest the warm reflected light from the porch roof. Add a wash of Yellow Ochre and Cadmium Orange to the porch ceiling.

Indoors, Looking Out

Here is where your study of light and light source, of reflected light, and of objects being hit by these lights will be challenged. Reflected light from outside will enter a room or area and illuminate the objects in it, but with differing amounts of light. This means some objects will be more important (nearest the light source) and others will fade in importance (farthest from the light source). A quick thumbnail sketch will help you sort out the wide range of values.

When the scene outside is more important, the objects in the foreground have to take a backseat. But remember the foreground objects should set the stage for your visual track to the point of interest (outside). Keep the foreground somewhat quiet—quiet in color and quiet in importance. Study your foreground and find out what you can leave out or tone down in importance.

RICHARD K. KAISER
"R.J. Olsen's Shack, Cushing, Maine"
Watercolor, 10" × 14" (25cm × 35cm)

R.J. Olsen is the nephew of Christina Olsen (of Andrew Wyeth's famous painting). R.J.'s lobster shack is packed with trapping equipment, ropes and buoys. The light from two windows and the doorway made this scene a challenge to paint. (There is a window behind the door.) You must move from diffused lighting (at the left rear) to backlighting (in front of the window) to side lighting (behind and in front of the door), to a mixture of all three in the left foreground.

RICHARD K. KAISER
"The Weighing Shed, Port Clyde, Maine" Watercolor, 10" × 14" (25cm × 35cm)

Port Clyde has all the boats and wharfs and lobster shacks you could ever want to paint. In this painting the outdoor area is the center of interest. The interior portion, though full of interesting shapes and colors, was kept muted. It's important in a painting like this to keep the values fairly uniform in the area of secondary interest. Value contrast attracts our attention like nothing else in a painting.

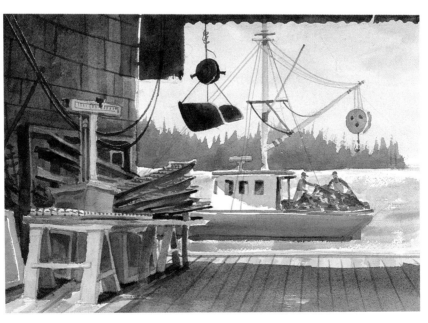

Objects that are backlit should be painted simply, with just enough detail to indicate form and subtle shadows.

Light is coming from two sources here, the doorway and a window behind the door. The light from the window is hitting the yellow buoys. On the door the tones of the shadows tell you where the light is coming from.

Backlighting makes dark silhouettes of the tin overhang and the scales. Mix Ultramarine Blue and Burnt Umber to make a dark. While it is still damp, add strokes of Alizarin Crimson to give warmth and life to the shadowed side.

There are multiple light sources here—the dock overhanging the water, the open side of the building and a window behind the viewer—all affecting the shadow wash on the floor. Paint a mixture of Raw Sienna and Raw Umber across the whole floor. When it is dry, add the shadow of Burnt Umber with a little Ultramarine Blue. The shadow wash is darkest where it contrasts with the sunlit portions of the floor.

The Light and Shadow Families

Everything you see can be broken down into two distinct halves: light and shadow. If you squint your eyes as you look at your subject, it is easier to see their respective patterns. All parts of your subject that are more directly illuminated by the main light source are considered members of the light family, while the shadow family is made up of all areas not directly lit by the main light source. There is a link between all the light and a link between all the shadows. Both may be influ-enced by indirect light, such as re-flected light bouncing into shadows, but separate the basic pattern of light and shade at all costs. It is better to push the extremes. For example, a white vase becomes a part of the shadow family if it is immersed in shade; a dark object's local color may be very dark, yet parts of it may belong to the light family if it has light shining directly on it.

To reinforce this pattern, it is helpful to analyze your subject in black and white. Use a thick, pointed black marker to indicate all areas in the shadow family in solid black. Leave the white paper for areas in the light family.

Do not confuse darks with shadows. Dark objects receive light and shadow too. If a white object is in shade, fill it in solid black. If a black object is in light, leave it white. This separates the process of clarifying light and shade from the process of seeing color.

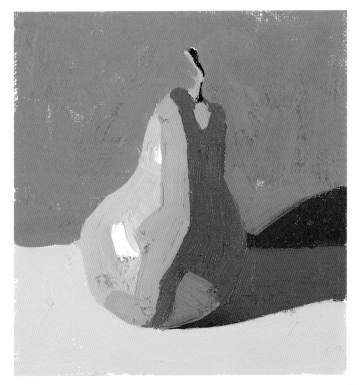

Full Color
The light and shadow families are rendered in full color notes, with the components of each family simply stated.

Defining the Families

The *light family* includes surfaces more directly illuminated by the main light source. It includes highlights, or planes angled toward the light source, and halftones, planes angled slightly away from the light source. The *shadow family* includes planes not directly illuminated by the main light source. It includes planes angled away from the light source, areas where no light falls, and cast shadows where the light is blocked by an object casting a shadow on another surface. Reflected light can be bounced back into a shadow, filling the shadow planes with more light and color than if the reflected light were not there. Squint to see it disappear.

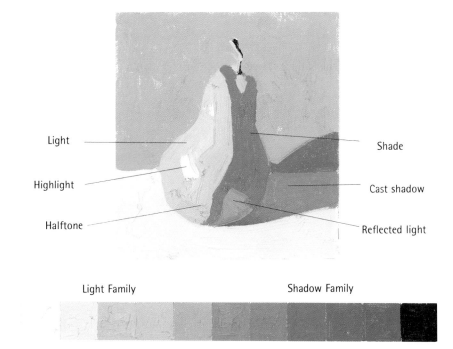

Light Shade

Highlight Cast shadow

Halftone Reflected light

Light Family Shadow Family

Black-and-White Values

Colors have an inherent value, as represented in this black-and-white version of the full-color reproduction shown here. If you determine the correct color note, you will automatically obtain the correct value.

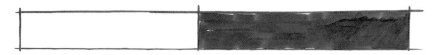

Sketch

A study in black and white clearly separates the families, distinguishing the most obvious contrast.

Art by Kevin D. Macpherson

Simplifying the Families

If there are many separate lights or shadows describing a form, link them somehow to create more simplified shapes, while still maintaining your overall light-and-shadow pattern. For example, the snow pattern in illustration A is scattered and disorganized. In illustration B, the simplified rivers of light and shadow make for a stronger, simpler painting. Connecting and creating larger shapes makes for a more organized, flowing pattern.

A—Wrong

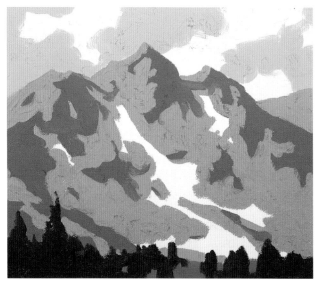

B—Right

Art by Kevin D. Macpherson

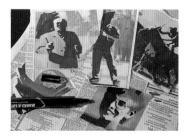

Marker on Newspaper

Reinforce the concept of the pattern of light and shadow by doing exercises on newspaper pictures or actual photos. Analyze the photos, then fill in the shadow shapes in solid black.

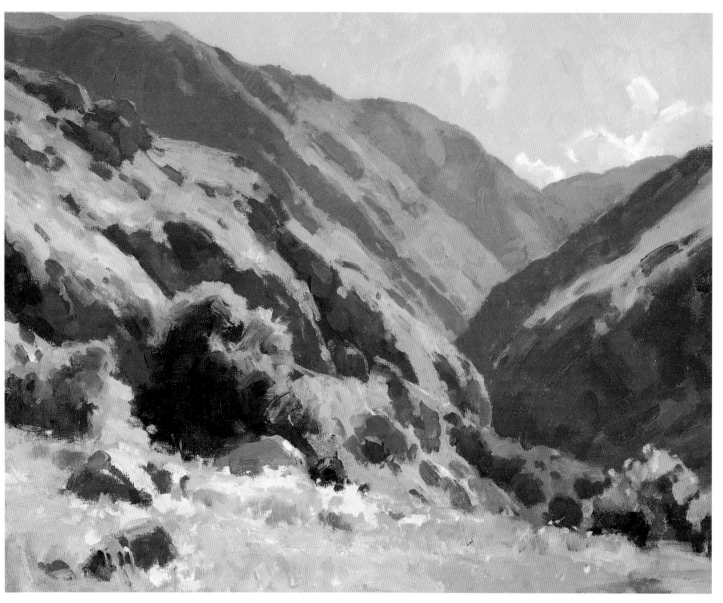

Consistent Yet Varied Patterns

This painting has a very obvious pattern of light and shade, yet each shape in both the light family and the shadow family is filled with color and variation.

KEVIN D. MACPHERSON
"California Canyon"
Oil, 16"×20" (40cm×50cm)

SQUINT!

Get in the habit of softening your focus and squinting: Soften your focus to see color, squint to see contrast. But don't paint as dark as you see when squinting.

Adding Variety to the Families

Color changes occur within both the light family and the shadow family. You want to fill the shapes in each family with glowing color. While shadows have less light, they are greatly influenced by the power of reflected light to fill them with glowing color. Such indirect light adds variety and form to the shadow family. Highlights and halftones add interest and form to the light family. You will destroy the families if the value changes within them are too abrupt. Look for color temperature changes (warm and cool) first, instead of value changes. Destroying your light-and-shadow pattern will create a "muddy" painting.

LIGHT REFLECTS AT ANGLES

If you understand how light reacts when it hits an object, it will help you determine the color note of a specific plane. Direct light reflects off the surface of an object at a right angle, 90°. The more directly the light hits the surface, the lighter it will be. As the angle becomes more oblique, the plane will be less and less influenced by the light source, whether it is a main source or reflected light. If you know the angle at which two planes face each other, think about how the reflected light from an opposite plane will hit the plane of the object you are painting.

SHADOWS FIRST

Establish your shadow patterns first, even though they will change rapidly outdoors. Painting the shadow shapes first is very important to assure clean, bright color and a consistent pattern of light.

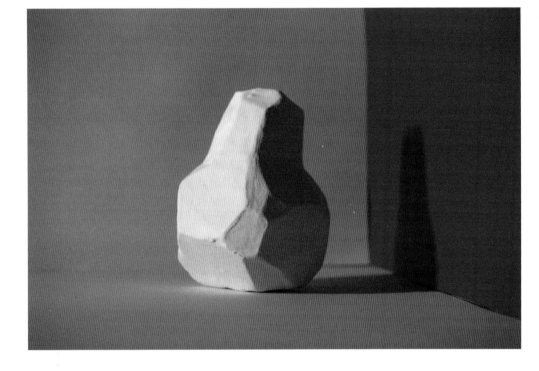

Look for the lightest light and the darkest dark.

Reflected Light

A strong main light source establishes the light and shadow families. In the light family, many of the planes on the far left surface of this object are in direct light, while the halftone plane facing down towards the floor picks up reflected yellow light as it turns away from the main light source. In the shadow family, planes facing the red wall receive red reflected light. Even the cast shadow on the yellow floor is influenced by the red wall, turning that shape orange. The shadow planes facing the yellow floor directly appear to be the most yellow, while those influenced by both the yellow floor and the red wall appear more orange as they turn towards the wall. Yet reflected light is not strong enough to destroy the shadow and light families. The influence of various light sources on planes is more easily seen on white objects, but it is necessary to see them on colored objects as well.

You Can't Cast a Shadow on a Shadow
If you cast an additional shadow across your forms, you will find that it casts only on the light family, and fades into the shadow family.

LIGHT AND SHADE Q & A

Analyze your subject:

1. Where is the light source? Knowing at what angle light hits planes helps you determine how they are receiving light.
2. What color is the main light source? This influences your whole light family.
3. Where is the darkest dark in the shadow family?
4. Where is the lightest shade in the shadow family? This is usually darker than the darkest color note in the light family.
5. Where is the darkest color note in the light family? This is usually lighter than the lightest shade in the shadow family.
6. Where is the lightest light in the light family?

Paint Light and Shade

KEVIN D. MACPHERSON

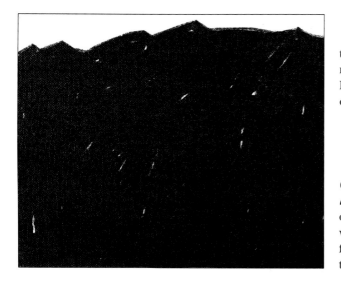

1 VISUALIZE THE SILHOUETTE
The biggest contrast in the landscape is between the sky and the land. The sun and sky are usually lighter than all natural elements on earth because the source of light is the sun and the sky. If the day is sunny, the light is warm. If it is overcast, the light is cool.

2 LIGHT AND SHADE
The shadow family and the light family are the second most obvious contrast. On your sketch pad, block in all shadow areas with black marker. Throughout the painting process, the shadow family should remain darker than the light family. Don't destroy this relationship.

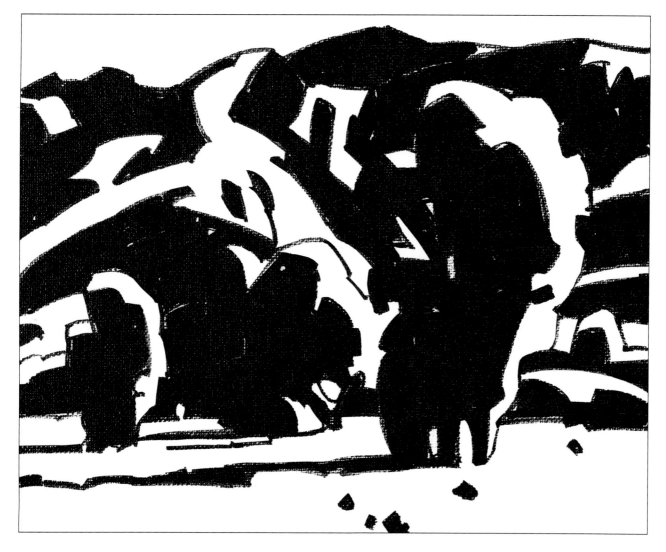

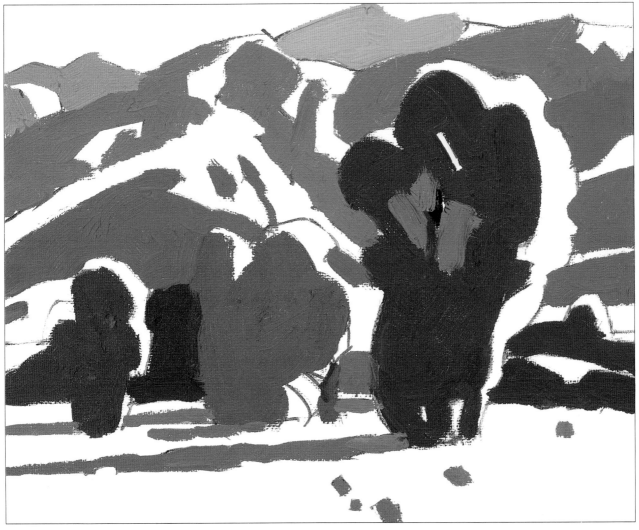

3 COLORFUL SHADOWS FIRST

Once you establish your value range with lightest light and darkest dark, it is best to establish the shadow pattern.

Organization

Applying color notes in a haphazard way, though they may be correct, makes it much harder to judge relationships. Compare this example to steps 3 and 4, which are organized and under control.

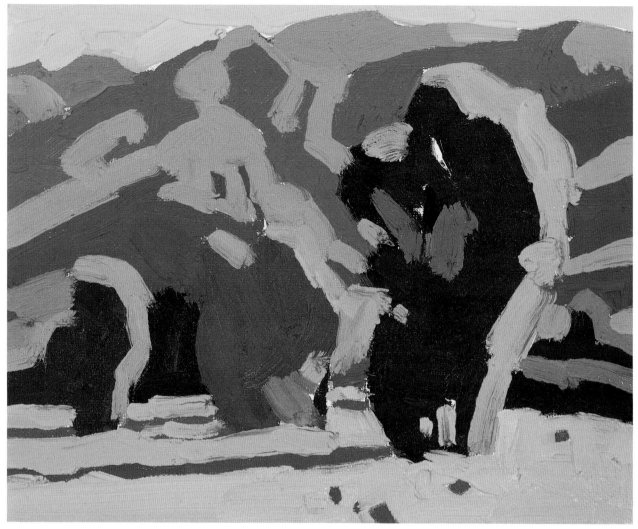

4 FILLING IN THE LIGHTS

Cover the canvas with clean color notes, making sure the painting maintains the silhouette established in step 1, and the light-and-shade patterns established in step 2. If it doesn't, make corrections so that it does.

HINT

Leaving the sky for last keeps you from painting it too dark, which would make you paint the land even darker. Key the sky to the land if the land is the main subject. However, when painting a sunset or featuring cloud patterns, do the sky first and key the land to the sky.

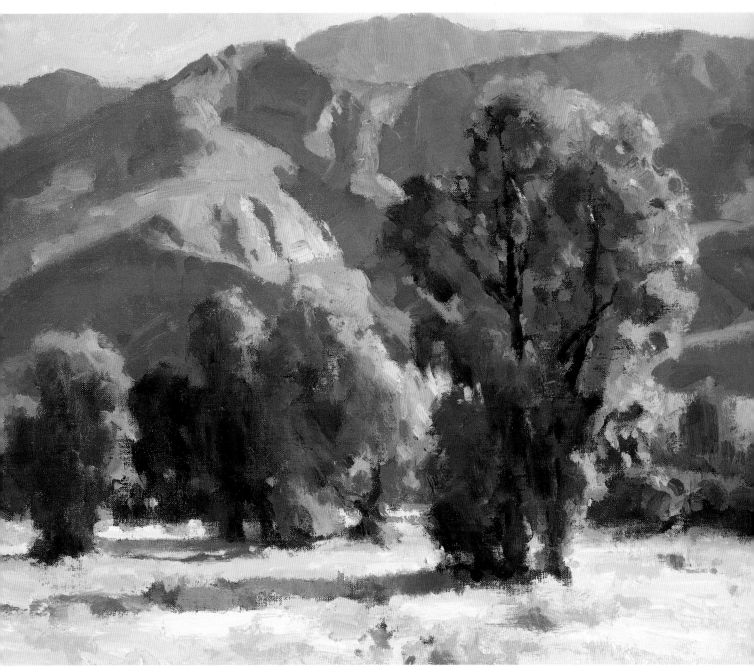

5 THE FINISH

Once the overall color pattern is established correctly, look for subtle changes and variations within shapes. Divide the larger masses into smaller ones, if necessary, without destroying the basic shapes. Then step back, turn away, walk away, rest your eyes, take a deep breath or wash brushes. When you are refreshed, come back to the painting with a renewed sensibility, and add finishing touches.

KEVIN D. MACPHERSON
"Palm Desert"
Oil, 16"×20" (40cm×50cm)

The more you learn, the more you know. The more you know, the more you know you need to learn more.

Painting Sunlight

One of the biggest challenges artists face when painting sunlight is that it is not something which is physically tangible. Instead, it is more of a transformation, affecting your surroundings. Painting sunlight does not just involve painting blue skies. You must create an atmosphere of warmth and luminosity through constantly observing and judging tonal values. The artist who learns to paint sunlight understands the importance of reflected light and vibrant shadows, and treats them as a positive part of the composition.

Dark foliage drybrushed onto dry surface.

Art by Zoltan Szabo

Wet-lifted sun

When painting a sunrise or sunset, remember that nothing can be brighter than the light source—the sun. For Zoltan Szabo, the trickiest parts of this sketch were the hot-color charges in the tree trunks near the bright sun. He started by painting the background onto a wet surface. He began with Ultramarine Blue at the top, and moved his 1-inch (2.5cm) soft slant brush with a curving motion around the sun's circular shape. Where the sun is located, he dropped in a heavy splash of Gamboge Yellow and surrounded it with glowing Cadmium Red-Orange. All these washes blended into each other. The warm, dark foreground came from a mix of Phthalo Green, Rose Madder and a bit of Cadmium Red-Orange. As the color was drying, Szabo lifted out much of the Gamboge Yellow and the light color of the sun resulted, establishing his lightest value. After the paper dried, he applied the very dark silhouette of the trees' foliage with the flat side of a heavily loaded 2-inch (5cm) slant bristle brush, lightly touching the dry paper. Szabo charged the wet washes near the sun, as well as the reddish brown middle-ground trees on the right side, with a lot of Cadmium Red-Orange. The result is hot-color dominance and very high value contrast.

Close to where he planned the sun's location, Zoltan Szabo charged the dark, wet foreground wash with Cadmium Lemon, Cadmium Orange and some Magenta to echo the powerful light of his light source. When that was dry, he masked out a circle shape, and with the 1-inch (2.5cm) slant brush loaded with clear water, he scrubbed off the color and blotted it into a paper tissue, exposing the light shape of the sun. Because the color looked a little too white, he tinted it with a bit of warm yellow color.

ZOLTAN SZABO
"The Last Wink"
Watercolor on Noblesse cold-pressed paper
13¾" × 18" (34cm × 45cm)
Collection of Ruth and Jack Richeson

Capture Sunlight on Location

KEVIN D. MACPHERSON

*P*ochade (pronounced poe-shod) is the French word for rough sketch. It is a small painting done very quickly, with few strokes. Capturing sunlight this way, a small bit at a time, is convenient and produces fresh, beautiful results.

Working small has many advantages, the first of which is speed. Doing small, *alla prima* paintings (paintings finished in one session) is sometimes the only way to capture very fleeting moments such as storms, sunrises or boats on the sail. Speed is essential for capturing the fleeting effects of light. The most dramatic lighting often occurs in the early morning and late afternoon, when the sun rapidly changes colors and shadows. Being able to paint quickly at such times is a must.

Artist Kevin Macpherson has done hundreds of these pochades, usually on 6″ × 8″ (15cm × 20cm) panels. This demonstration and the next are two examples.

1 ESTABLISH THE BIG SHAPES

Begin with a quick sketch, and map out the important shapes with a large brush. Find the lightest lights. Using bold strokes, place your first color notes, here the warm whites of the boats, flatly and simply. Compare the slight color temperature changes of each other light shape. Next indicate the darkest dark, concerning yourself with the accuracy of the color note rather than carefully filling in the drawing. The drawing is just a map. You will quickly lose it, because you are constantly going over it, drawing proportionally placed shapes with your brush.

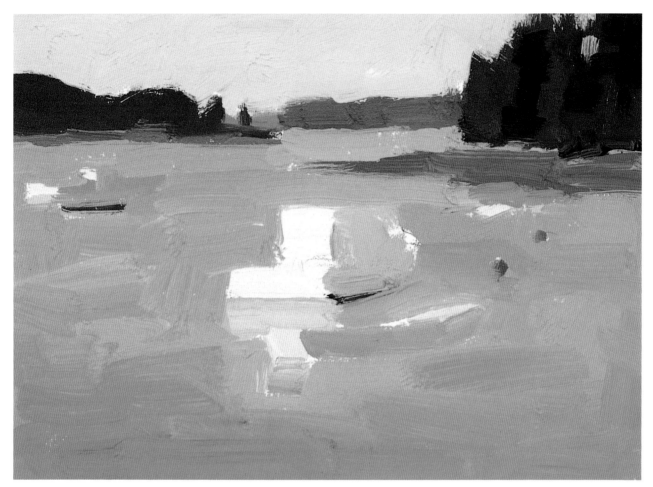

2 PAINT THOSE SHAPES

Cover the entire panel with an arrangement of flat shapes, painting the colors and values as accurately as possible. Each color helps you judge the next one.

OBSERVE CHANGES

Each subject more or less directs its own painting process. Boats will often move the whole time you're painting them. Water changes patterns, so always be observant. As your work progresses, pick the patterns that best help the painting. Work on one boat while it's at the angle you want, then go to another as it changes.

Make quick, direct decisions. Time is short.

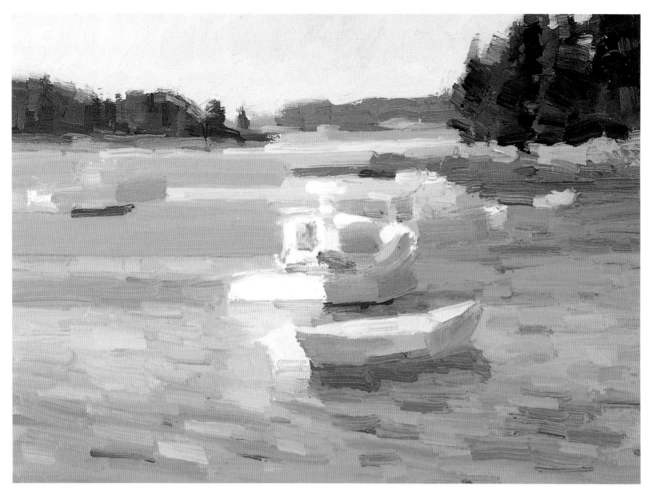

3 REFINE AND MODIFY
Once you have the entire panel covered, step back and evaluate your color choices. Examine each shape, asking yourself if anything needs to be lighter, darker, warmer or cooler. Then make the adjustments. Modify larger shapes, such as the background trees, with smaller touches of color. Look for nuances and variations. Adjust values, soften or sharpen edges, and clarify any confusing areas. Break down the original shapes by painting more simple shapes within them, being careful not to destroy their general colors and values. Add as much variation as you please, but think it out. Less can often say more.

HOUR–A–DAY CHALLENGE
Spend an hour a day for three months painting one 6″×8″ (15cm×20cm) painting every day. That's nearly one hundred paintings! Paint from life or memory, and don't worry about finishing. Number the backs of your canvases to mark your progress. You're guaranteed to improve, and your paintings will naturally look more finished without your having to consciously think about it.

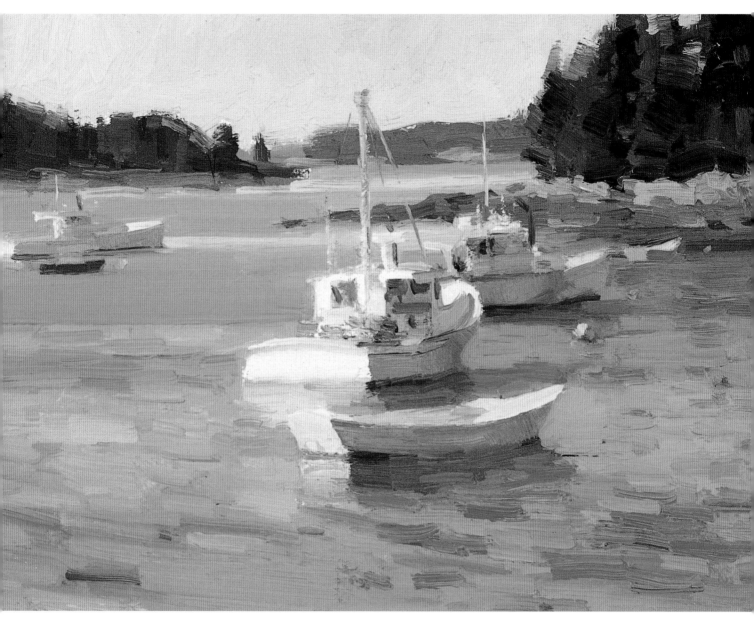

4 JUST ENOUGH DETAIL

Carefully thinking about every stroke and using the largest brush possible, add only those details (smaller shapes of color suggesting what you see) needed to define the subject, such as the gear on the boats. Continue to refine the painting, going from shape to shape, working big to small. Just as you divided the panel into a dozen or so shapes, you can divide all those into however many you choose. Concern yourself with soft and hard edges. Very little detail is necessary. If the shapes, color and values are right, the correct impression is already there.

If it is correct, leave it alone.

KEVIN D. MACPHERSON
"Maine Sparkle"
Oil, 6″ × 8″ (15cm × 20cm)

More Painting on Location

KEVIN D. MACPHERSON

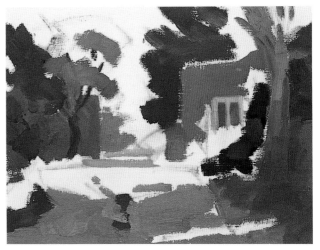

1 ARRANGE THE ELEMENTS
Quickly map out the important elements of the composition. Being in control from the start makes the painting process easy.

2 COLORFUL SHADOWS
This composition already has a feeling of light with only the color notes of the shadows laid in.

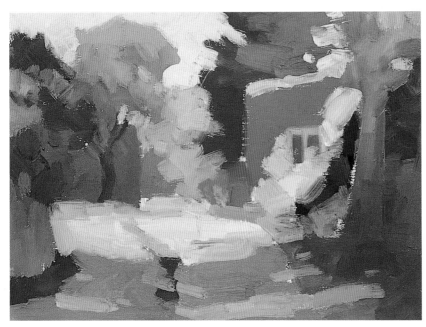

3 FILL IN LIGHTS
The overall light-and-shade pattern is established.

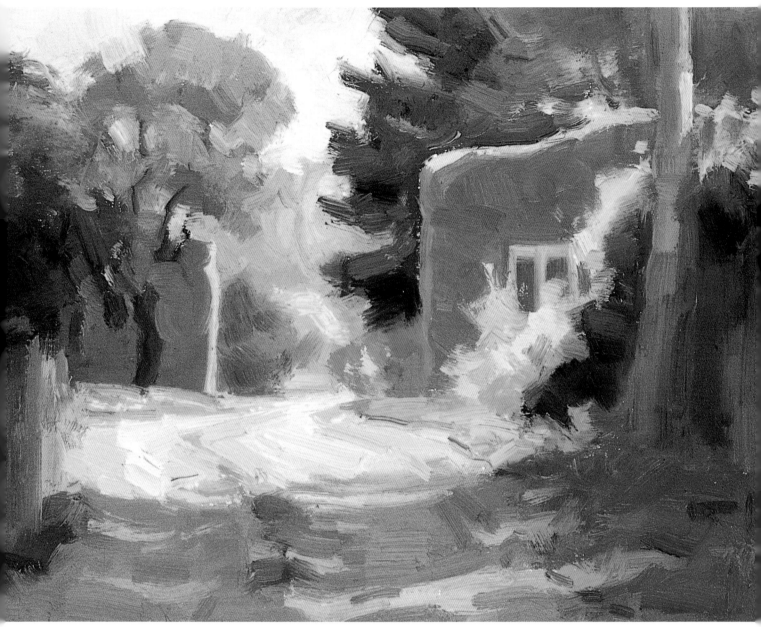

4 ADD VARIETY
Complete the painting with subtle warm and cool variations, as well as attention to the edges of shapes.

KEVIN D. MACPHERSON
"Santa Fe Alley"
Oil, 6"×8" (15cm×20cm)

NO MUDDY COLORS

Wipe your brush with a tissue after every stroke, and scrape your palette frequently with a palette knife.

Gallery of Pochade Paintings

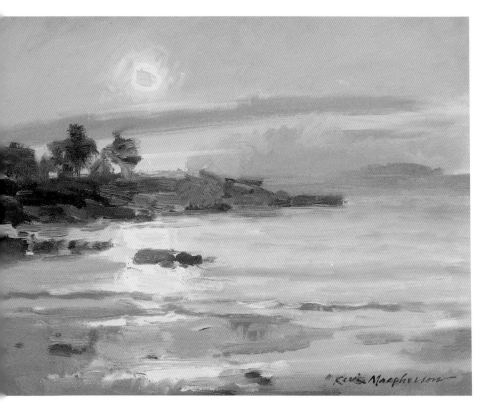

KEVIN D. MACPHERSON
"Wipe the Sand From My Eyes"
Oil, 6"×8" (15cm×20cm)

Trust What You See

This Maine sunrise moved so quickly, artist Kevin Macpherson had to race to capture it and the colors reflecting on the gently moving water. He painted the center of the brilliant sun Winsor Green and white—something he never would have imagined in the studio. He saw it and trusted his eyes. When completed it gave a feeling of intense brilliance.

Don't discount it because it came easily.

KEVIN D. MACPHERSON
"Albonegan Morn"
Oil, 6"×8", (15cm×20cm)

Nature's Subtleties

Every sunset or sunrise takes on amazingly different harmonies. Photographs Macpherson took of this scene did not reveal any of the subtle color temperature and value changes he captured from life, especially in the sky. Painting from life brings out unexpected combinations and challenges, which keeps you coming back time and again.

KEVIN D. MACPHERSON
"Solitude"
Oil, 6"×8" (15cm×20cm)

Speed Skills

Macpherson's speed skills developed from endless *plein air* paintings are so important for situations such as the one when he did this piece. The wind was blowing fiercely at Dana Point, California, and the last hour of sunshine was in front of him. As he sat below a cliff, bracing his wind-blown easel, a pregnant mother with her young child passed by ever so quickly. He jotted their gestures down within seconds, and left them alone. "Sometimes you win and sometimes you lose," says Macpherson. "I think I caught this one."

KEVIN D. MACPHERSON
"Dublin Flower Market"
Oil, 6"×8" (15cm×20cm)

Simple Color Spots

In this piece, Macpherson tried to very loosely capture the early morning light of the Irish outdoor market. However, the lack of detail does not diminish his memory of colors, light and chilly air that day. The faces are just simple color notes, no details, but they are still believable. Perhaps more detail would have taken away from the whole.

Add Sparkling Sunlight to Still Lifes

Sunlight is a wonderful tool to add bold contrasts, luminous shadows and mood-elevating, high-key colors to your still lifes. Where the sun rests on objects, it appears to bleach them near white. Where it passes through transparent things, like a flower petal, a leaf or colored glass, it brings out intense, jewel-like color saturation. Sunlight will bounce reflected color all over your still life. Intriguing patterns are created by cast shadows of arrangements.

LIGHTING YOUR SUBJECT WITH SUNLIGHT

Set up your still life to take advantage of available sunlight. A window as your light source can result in dramatic effects in winter, when days are short during the months before and after the winter solstice. Sunlight streams into windows casting long shadows from the sun's low placement in the sky. This is especially true if you live in a cold climate with no leaves on the trees to filter out the weaker winter sun. Colored glass on a windowsill produces vivid colors and reflections.

If you have trouble getting enough light on your subject, take the setup outside. You can, for example, place formal arrangements outdoors on an ironing board, turning them in any direction to catch the light and adjusting up and down for the right eye level.

Placing a board in back of the setup covers distracting backgrounds. You'll be amazed how quickly the light changes as you arrange your shapes. Indoors you can set up one day and photograph the next if the changing light has left by the time you are ready to shoot.

Orchestrating the light and shadow of your still life is a matter of turning, raising and lowering the arrangement to catch the sun from different angles. Experiment until you're satisfied with the result. Observe the effects of the different angles of the sun in the examples on this and the next page.

Three-Quarter Light
The sunlight on this arrangement has been aimed at a three-quarter angle that accents the forms of the objects and the cloth. Long shadows are cast against the backdrop, while the table in shadow appears very dark.

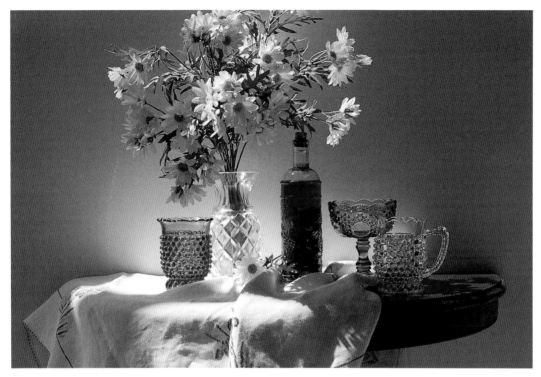

Side Light

An interesting effect is achieved by light coming from above at an angle that spotlights the setup on one side; shadows play over the flat surfaces, unifying the value patterns.

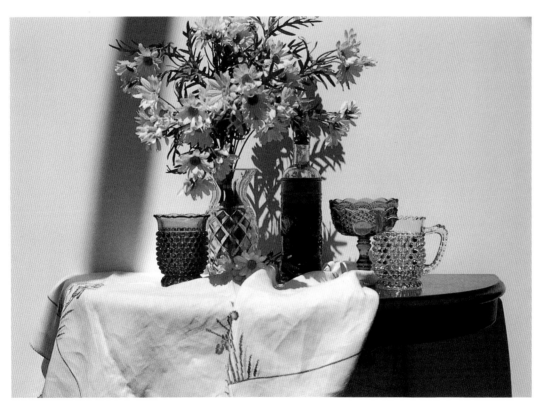

Front Light

Some modeling of forms and interest is lost with front lighting; look at how flat the cloth appears, and how its shadows are barely visible; the objects no longer cast much of a shadow either. In this case, it is the most uninteresting of lighting choices.

Try Backlighting

Light from behind your still life brings out strong color saturation in the transparent objects and haloes of light around the opaque ones. The outline of your composition becomes more important as your arrangement appears as a near silhouette. Areas not in the light will have closely related values. Flowers and plants have a translucency that is especially revealed with backlighting.

Backlighting
Here, an arrangement has been placed with its back to a glass door, which creates a confusing background. Yet the color saturation of the colored glass as the sunlight passes through it is dramatic, and strong patterns of light on the tabletop contrast with the cloth in dark shadow in the foreground. The glass objects have haloes of light and cast colorful shadows.

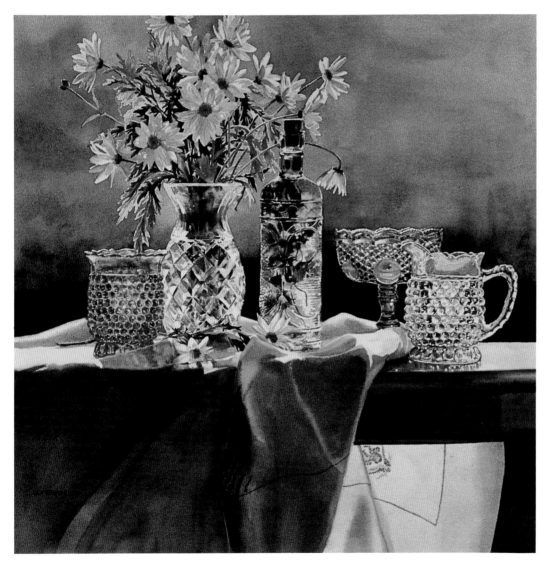

LIZ DONOVAN
"Window Glass"
Watercolor, 20"×21"
(50cm×53cm)
Collection of Drs. John and
Barbara Rock

In the final painting, the background is simplified and the foreground is darkened to make the light areas stand out.

Observe Reflected Light

Look for colored light bouncing into the shadows of your sunlit arrangements; this reflected light will be lighter than the shadow, but darker than the sunstruck areas. Reflected light adds luminosity and also helps model form.

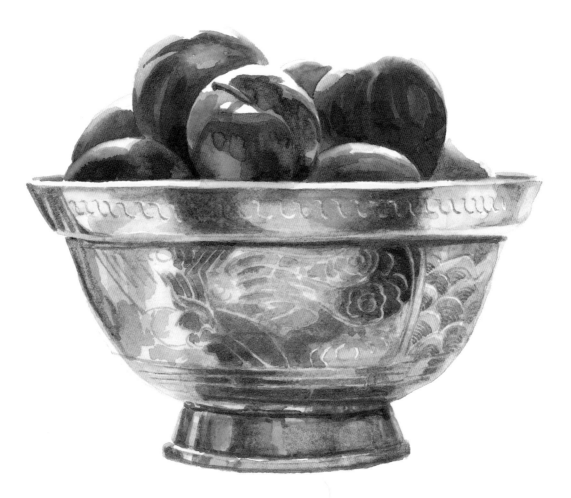

Reflected Light
The sun shining behind a brass bowl of plums casts rims of light around them; reflected light bounces up onto the bowl from a sunlit table surface. This reflected light is never as light as direct sunlight, even though the local color of the brass is lighter than the dark purple plums.

Same Scene—Different Light

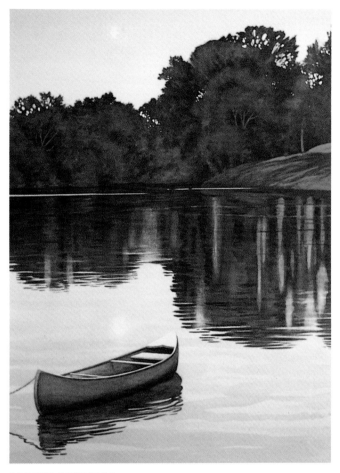

ROBERT REYNOLDS
"Symphony Suite: Full Moon"
Watercolor, 35" × 24" (88cm × 60cm)
Collection of Elizabeth Rochefort

ROBERT REYNOLDS
"Symphony Suite: Golden Light"
Watercolor, 35" × 24" (88cm × 60cm)
Collection of J.M. Biddle

Full Moon

This painting captures the faint image of the full moon during late daylight hours. In this version, the canoe serves as a gentle reminder that people have been or will be here.

Golden Light

Here, the warm light of early morning results in a completely different effect and a very different feeling.

The next time you paint one of your favorite subjects, why not try creating several different versions that express variations in lighting conditions? It's an excellent way to challenge your visual and artistic senses to see and express the mood of a scene more clearly.

And don't worry about repeating subjects. There's always something new to be said about a scene if only you look hard enough. In the *Symphony Suite* series on these two pages, the same scene and basic composition is used four different times to explore the effects of variations in light and color as well as in smaller design elements (the boat, grasses, egret and so on). Each painting was done with many overlapping, graduated color washes applied with a wide hake brush, and each has a subtly different mood.

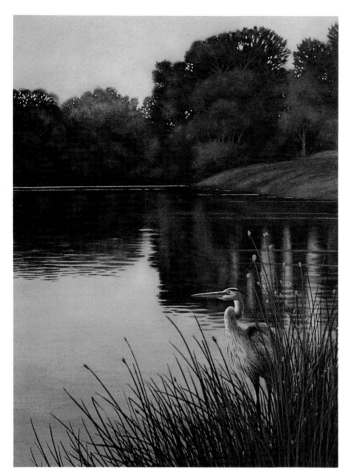

ROBERT REYNOLDS
"Symphony Suite: Blue Heron"
Watercolor, 35″×24″ (88cm×60cm)
Collection of Elizabeth Rochefort

Blue Heron

In this version, fading light of the setting sun creates a competely different feeling once again as the light strikes the treetops.

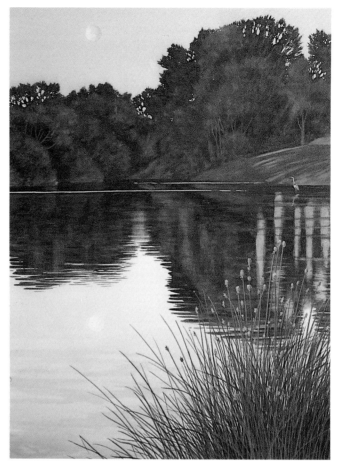

ROBERT REYNOLDS
"Symphony Suite: Indian Summer"
Watercolor, 35″×24″ (88cm×60cm)
Collection of Mr. and Mrs. Richard Equinoa

Indian Summer

In this final version, we again return to the theme of the full moon reflecting on the water, but with different elements. Without the foreground canoe, the mood is even more tranquil and the eye is directed by other foreground subjects, such as the vegetation that reaches up into the painting.

Use Light to Capture a Mood

WATCH FOR SUDDEN CHANGES OF LIGHT

Color is reflected light that our eyes process, and the two cannot be separated. It is through color and light that the incredible, often unexpected, beauty of the landscape can be explored in paint. *Titan Triumph* is an expression of that fleeting moment when a smile of light touches the terrain after the dark clouds of a thunderous, flashing rainstorm have passed. When you watch the light play over the landscape, the colors change constantly. It looks soft and seductive one moment, then harsh and frightening the next. It's the same land, only the light has changed.

MARY LOU KING
"Titan Triumph"
Watercolor, 22″×30″ (55cm×75cm)

Titan Triumph is done primarily in transparent watercolors. Working with underpaintings and glazes to achieve richer transparencies, artist Mary Lou King first applies layers of strong, vibrant, warm colors and then subdues them with cool glazes. In the shadows some pigmenting colors are used.

TRY A SPONGE FOR BACKLIT LEAVES

The effect of light on Montana's landscapes is a constant source of inspiration for Loren Kovich's dramatic paintings. Kovich always brings a camera along on floating and fishing trips to capture sudden inspirational changes in light. When the strongly backlit scene depicted in *Missouri River*

Afternoon was spotted, Kovich knew it was one of those "have to do" paintings. Besides the challenge of the light coming straight through the trees, just trying to capture the feeling of a warm late afternoon was incentive enough to do this painting.

LOREN KOVICH
"*Missouri River Afternoon*"
Watercolor, 22″×30″ (55cm×75cm)

The sky and foreground shadows were done wet-in-wet. To get the effect of the light coming through the trees, Kovich used a small natural sponge, painting the yellow sunlit leaves first, then the green shaded leaves. When the leaves were totally dry, a liquid mask was used on them so that the cliffs in the background could be painted right over the trees. Three glazes were used to get the cliffs dark enough.

PAINT WITH THE LIGHT BEHIND YOU

Paul Strisik has always been fascinated by the effect of light and the way it reveals the subject. But besides light, it is vital to incorporate in any work of art other factors such as good composition and design. In *Autumn Meadows*, the light effect is one of "flat light," meaning that the source of light is more or less behind the artist, causing shadows of objects to project into or away from the viewer.

PAUL STRISIK
"Autumn Meadow"
Watercolor, 20"×28" (50cm×70cm)

There was no special technique used in this painting. It is straight transparent watercolor technique. Some lifting of color to create tree trunks was used.

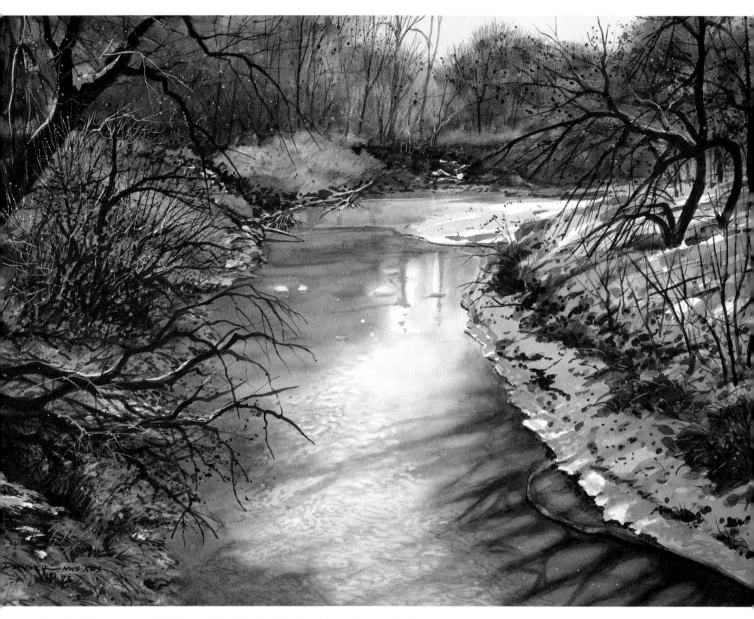

USE SOFT WINTER LIGHT TO CREATE A TRANQUIL MOOD

Light sets the stage for the overall complexion of the painting, setting the mood. This painting of the *Frenchman River* is a depiction of late winter. The sun is very low over the southern horizon creating very long shadows. The "glow" of the reflected light off the surface of the water is particularly evident, and is the focal point of the painting. The whole scene is bathed in the soft winter light, imparting a mood of tranquility.

DON DERNOVICH
"Frenchman Glow"
Watercolor, 21"×29" (53cm×73cm)

The soft appearance of *Frenchman Glow* was achieved by spraying a fine mist of water onto the surface from a spray bottle while the pigment was still wet, until Dernovich needed more control with edges and details. The glowing reflections on the surface of the water were achieved by masking out the shapes of the ripples with masking fluid. They were then glazed over with an application of color.

Painting People in Sunlight

In order to paint people in sunlight you need to know how to suggest form using the effects of light and shadow. You can't fake the light on a subject's face, so paint from life or use a good reference photo. Features are easily distorted if lights and darks are poorly placed. Establish your value structure early on, and make it work for you. Side lighting can enhance form; backlighting is gorgeous for flying hair and to achieve the feeling of a sunset.

Develop a Harmony of Color

1 THE INITIAL SHAPES
A student, John, stood outside Skip Lawrence's studio at Springmaid Beach. The sun hitting the back of his yellow shirt inspired this painting. John posed for a few minutes while Skip drew his shape and the shape of shade. The first paint washes identify the lightest values of local color. The yellow of the shirt is of prime importance and all other colors are reduced in intensity relative to the bright yellow.

2 THE SHAPE OF SHADE
Next paint the shape of shade. Paint your values accurately and with consistency. The shirt in shadow is not painted brown, which would negate the yellow shirt focal point, but a darker, brilliant orange. Proceed with other shadow shapes, being careful to keep color more neutral than the shirt.

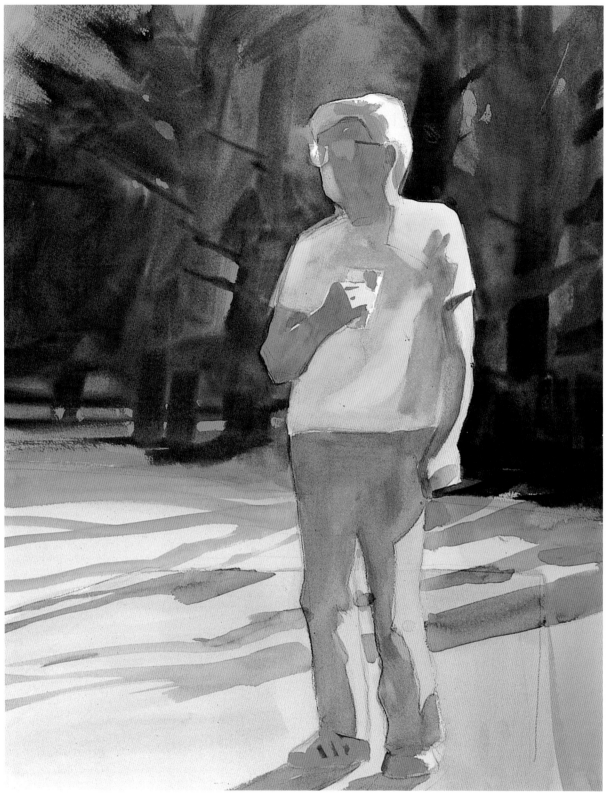

3 THE FINAL RESULT

To illuminate the figure, surround him with darker, cooler colors. There is only a suggestion of tree trunks and foliage so as not to detract from the figure. Shadows are cast across the lawn and patio as a transition from the dark woods to the sunlit foreground.

SKIP LAWRENCE
"Yankee Coffee Break"
Watercolor, 26" × 20" (65cm × 50cm)

Paint People With Value Contrast

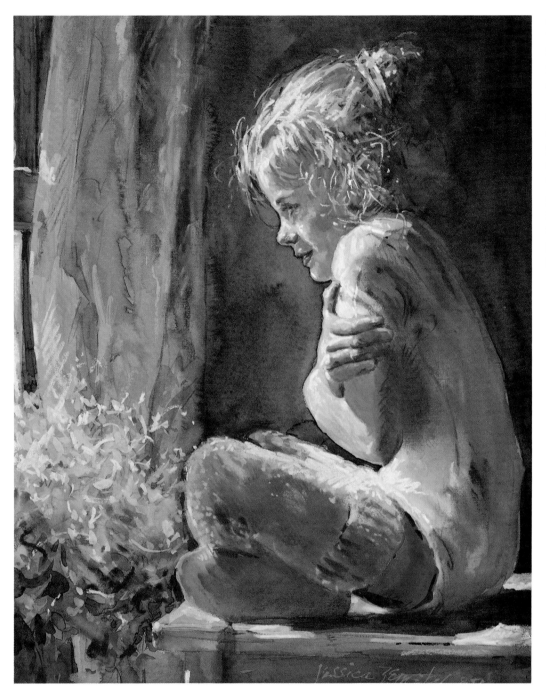

JESSICA ZEMSKY
"Robin in the Window"
Gouache, 24"×10"
(60cm×25cm)
Private collection

This is a good example of a value study. Sunlight streaming in from the left highlights the whites of the figure, while the shadow side, in purples and blues, goes quite dark. There are gradations from light to dark, and some soft, lost edges which melt the figure into the shadows.

Use light to create a feeling of balance in your painting, working lights and darks throughout a piece and keeping contrast in mind. What works for you? Are you painting a dramatic piece with intense contrasts, or all sunlight and brightness? Adjust your values to do the job.

HINT

If you can visually explain highlights and shadows successfully, you can leave out a lot of the middle values, and the viewer will still understand what the figure is up to. It's sometimes very interesting, involving and challenging for your audience to have a little work to do themselves, rather than having every inch of a piece spelled out for them.

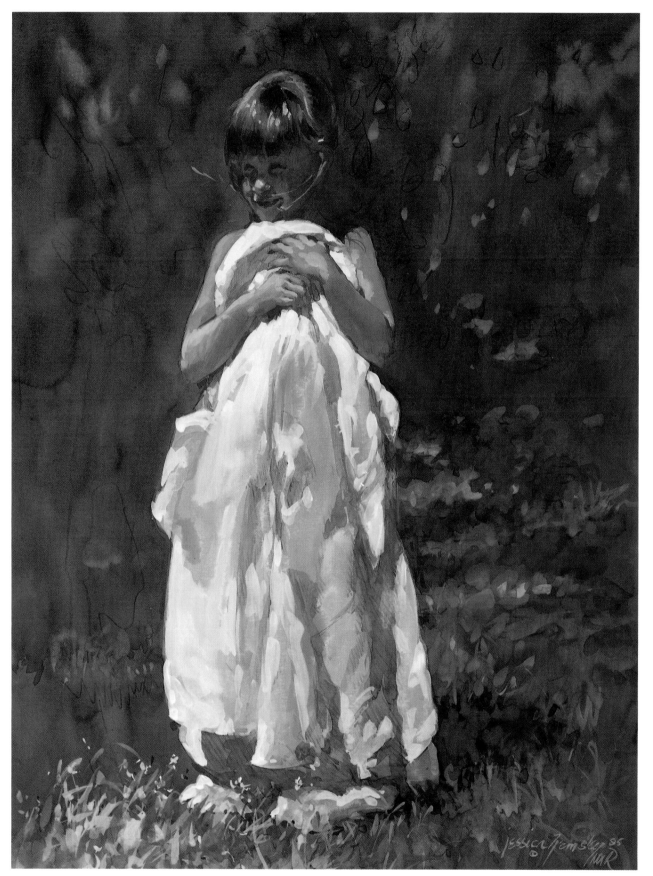

This girl in white, standing in front of dark trees, is a good example of contrast. Notice the hints of light in the background, and the dark colors of the trees and sky reflected in the white sheet. The dark shadow area on the girl's face also relates to the background.

JESSICA ZEMSKY
"One Sheet to the Wind"
Gouache, 24" × 20" (60cm × 50cm)
Collection of Mr. and Mrs. Harry Gerham

Create Mood with Light Temperature

Light temperature is important too. A cool light will suggest a calm, peaceful atmosphere—perhaps evening. Warm light suggests sunshine, heat, summer, joy, excitement. The effects of light are always important and need to be dealt with. Be aware of light, and use it to your advantage.

HINT

Darks suggest depth—dark areas seem to be farther back than lighter ones. Be judicious, and keep from making black holes in your foregrounds.

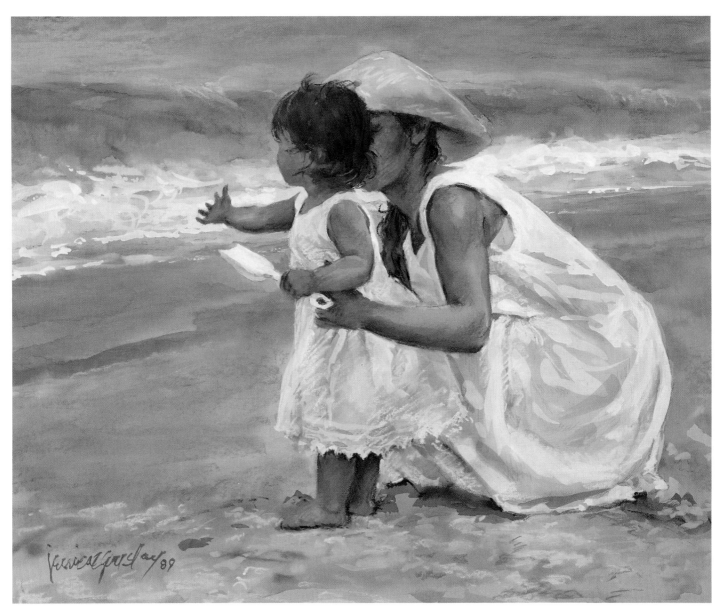

JESSICA ZEMSKY
"By the Sea"
Gouache, 16"×20" (40cm×50cm)
Collection of Jamie Aronow

These two paintings are good examples of light temperature. The one at the right has a warm, golden, indoor lighting situation that floods the room and the subjects with an intimate look. The seaside scene above is set in a more natural, overcast light, with a muted coolness reminiscent of salty sea spray.

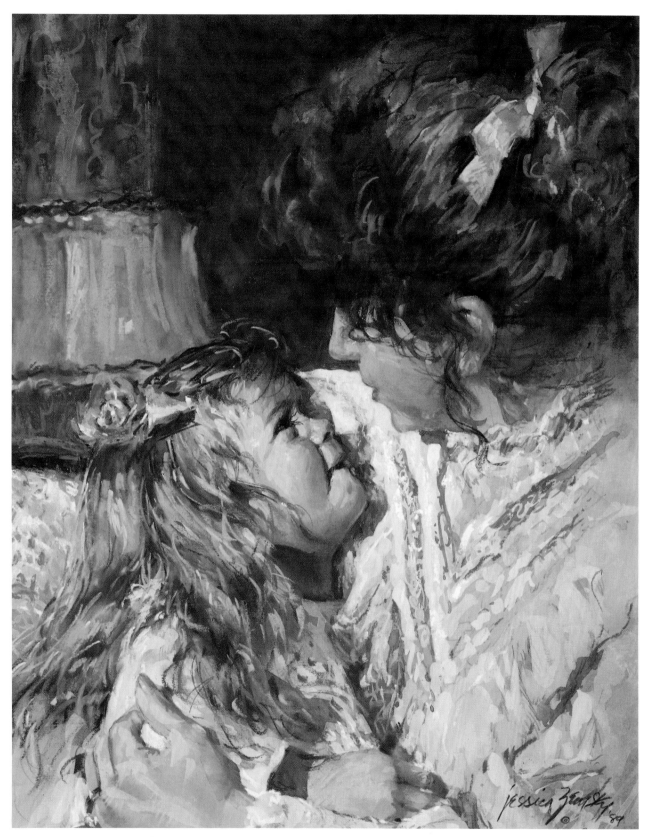

JESSICA ZEMSKY
"I Love You Mommy"
Gouache and pastel, 24" × 20" (60cm × 50cm)

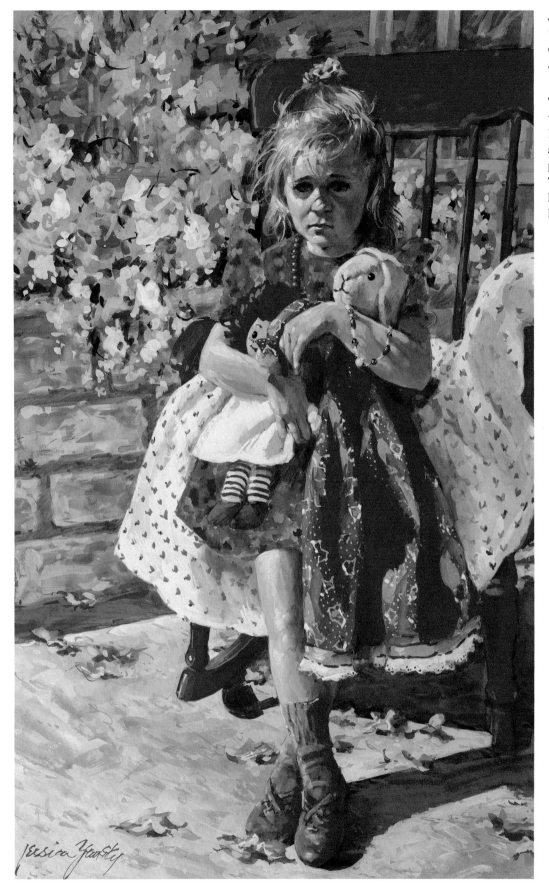

JESSICA ZEMSKY
"Blue in Pink Jellies"
Gouache and pastel,
30" × 26" (75cm × 65cm)

The light in this piece is very warm, even in the shadows. Even the coolest bits of blue are the warmest blue on my palette—Periwinkle Blue. The shadowed eyes have no highlights, though there are highlights in the dolls' eyes.

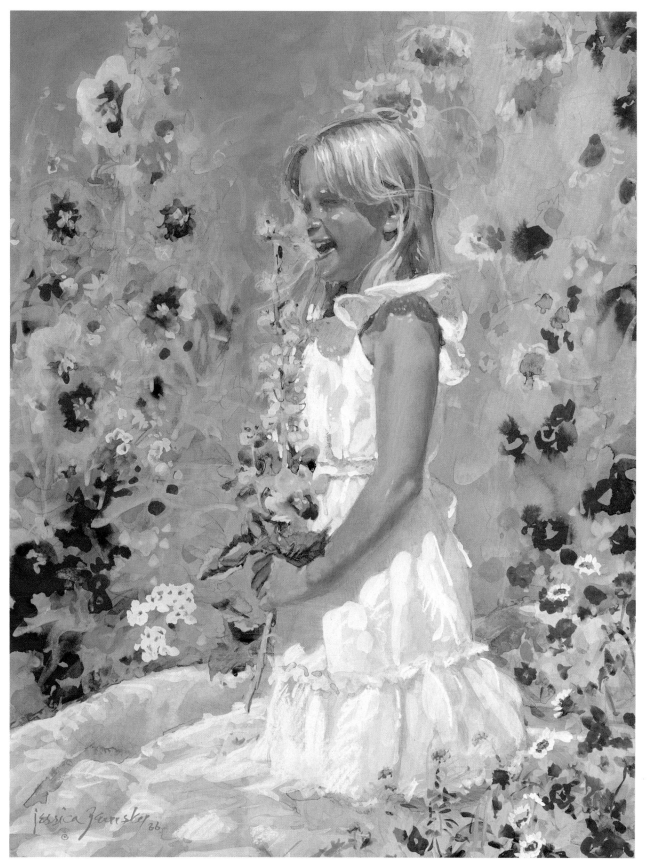

This painting is a good example of warm light used to depict sunshine, summer and joy. The whole thing expresses what light is all about: a clear Montana sky; flowers growing free in the sun; how white reacts to other colors in full light.

JESSICA ZEMSKY
"Take Time to Smell the Flowers"
Gouache and pastel, 24" × 20" (60cm × 50cm)

Paint People on a Warm, Sunny Day

TOM BROWNING

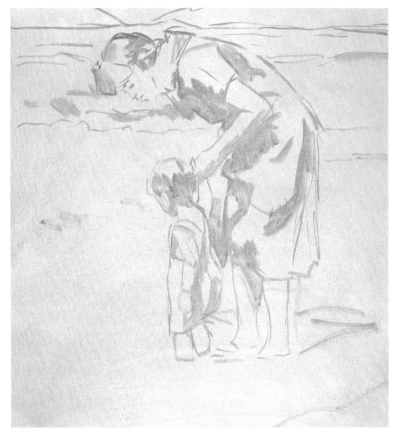

1 First tone your canvas with a very diluted wash of Yellow Ochre and Viridian (it dries very light, yet dark enough to let whites stand out). Using the same two colors, draw in the placement of the two figures and a few lines where the background will take shape. Don't be too concerned about accuracy, since you'll continue to draw throughout the course of the painting. Though these shadowed areas can be closer to their final values, they really only serve as a starting place for patterns that will later contain a lot more information about the light source and the form itself.

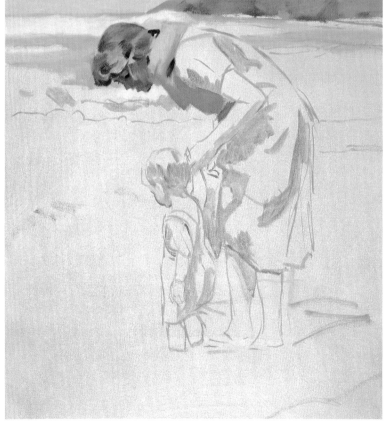

2 Begin painting with the area that will contain the strongest contrast. Because this contrast will attract the viewer's eye first, begin constructing a convincing head. After establishing the form's approximate values and colors, quickly begin putting colors and shapes into the areas around the head to give it something to relate to.

It's in this stage of the painting that you begin to establish a very key element to this picture: warm sunlight. Remember that values have to relate properly, and temperatures have to play their parts in order for the effect of a sunny day to be convincing. So as you paint the mother's head, keep thinking about the effect of warm light from the sun, cool light from the sky, reflected light and shadow temperatures.

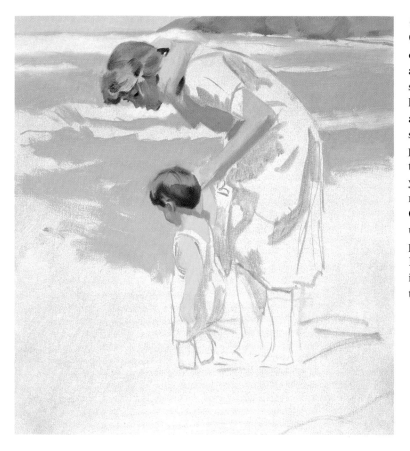

3 Use two simple values to begin creating form in the mother's arm. With the same colors, Yellow Ochre, Cadmium Red Light and Cadmium Yellow, begin establishing skin tones in the boy. As soon as the boy's head is roughed in, begin painting the water around it, not only to give the head some soft edges right away but also to have wet paint for controlling edges later. Although the water is blue from the blue of the sky, you don't want it to appear cold. So use a mixture of Cobalt Blue, Ivory Black, Yellow Ochre and White. This paint is basically an underpainting that's not too thick at this point, but certainly thicker than a wash. Keep this wet for the duration of the painting, so you can blend colors into it right up to the end.

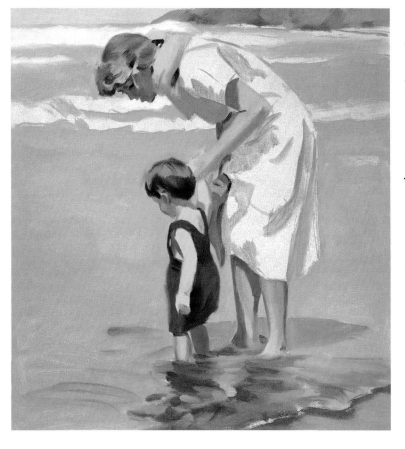

4 "The boy was actually wearing red," said Tom Browning, "but I debated whether I might run the risk of creating too 'loud' a statement with such an intense and saturated color. Although I often take the liberty of changing a color for a painting, I decided to go ahead and try the red. Then I stood back and could see that the viewer's eye would go back and forth from the boy to the mother's head, which in this case is just fine."

Finish laying in the water and establish the legs, using two values. The dark areas in the water below the figures represent reflections. While painting such reflections, try to capture the *character* of reflections in water. With a mixture of Yellow Ochre, Viridian and a touch of Cadmium Red, lay down some descriptive brushstrokes that would establish a subtle area of interest. At this point, you begin to see exactly where the painting is going and can easily relate values and colors to one another for appropriate changes and alterations.

5 Concentrate here on bringing the mother's head up to a nearly completed state. With a flat bristle brush, paint in the hair with various combinations of Yellow Ochre, Burnt Sienna, Viridian, Cobalt Violet and Titanium White. In the face, just add a little more contrast by darkening it with a warm mixture of Yellow Ochre, Cadmium Orange and Viridian. Shape and alter the mother's profile by chiseling into the face with colors from the background. Work a little more on the water and waves around the head, but stop short of actually finishing these areas.

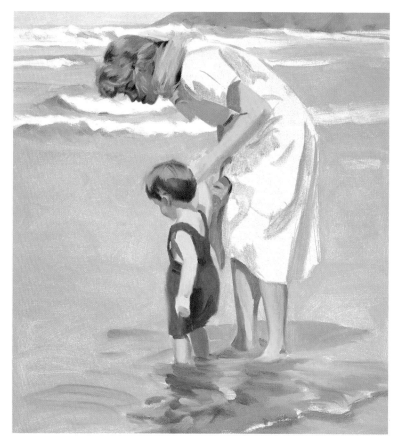

6 At this stage of the painting, bring the value of the water up a bit so that it appears a touch warmer. You want to make sure that the figure fits into its environment. You do this by making a mixture of paint using the same colors as before, just with different proportions. Brush some of this color into the water to the right of the figure so that the water is lightened by about two values. You can see the difference in values down the side of the skirt. At that point, begin painting in areas of the skirt that are adjacent to the background. What you want here is to achieve the proper value relationship and at the same time create some soft and lost edges that let the figure look as though it were truly a part of the scene, rather than being cut out and pasted on.

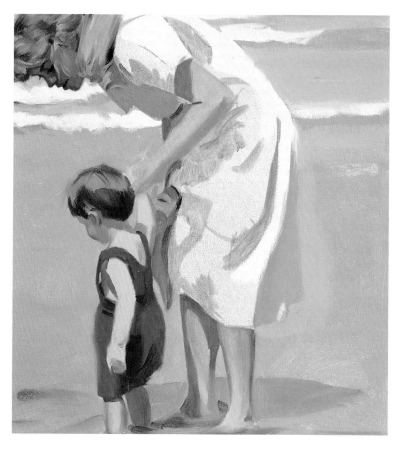

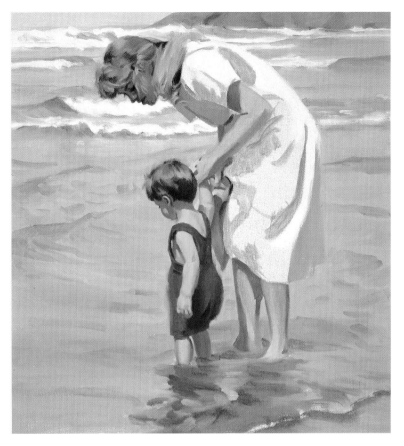

7 Continue painting the surrounding waters, correcting values, changing temperatures and adding accents that suggest movement. Add warm reflections to accentuate the effect of the sun on the water (you can see them below the wave between the two heads).

Still thinking "sunny day," paint back into the boy. For the proper effect, darken the overall tones of his skin. Just because something is sunlit, don't be fooled into thinking that the lighter you paint it the more convincing it will look. Quite often it's just the opposite. Remember that the subject is relative to everything around it. In this case the skin has to be darkened a couple of values to let the highlight areas read properly. Go on to create more convincing forms of his arms and back. Then take the head to a level that is about as finished as that of the mother, darkening shadows and modeling the hair.

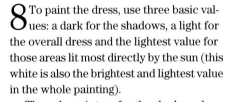

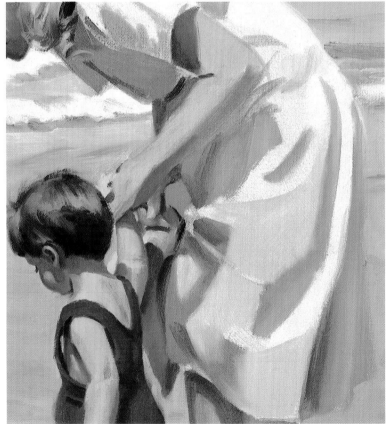

8 To paint the dress, use three basic values: a dark for the shadows, a light for the overall dress and the lightest value for those areas lit most directly by the sun (this white is also the brightest and lightest value in the whole painting).

The color mixture for the shadowed areas is the same as the water, but again, different proportions. Always keep temperatures in mind. Paint those areas that face the sky with a cool blue, while using warm blues and yellows for parts of the dress that face downward, reflecting the warm colors from below.

Break the lighted part of the dress into two values. It's only one or two values darker than the lightest value, but the difference is important. Otherwise, the whole dress would look flat.

9 To bring the dress closer to being finished, paint the lightest areas, working edges where light meets shadow, creating a variety of transitions. Another way of doing this is to paint in the entire dress with lighter values, then paint the shadows into the wet paint.

Go back to the mother's arm, adding thicker paint and defining the form. Suggest some reflected light under the forearm. Although it is barely noticeable, it serves to emphasize the round form of the arm and makes it a little more convincing.

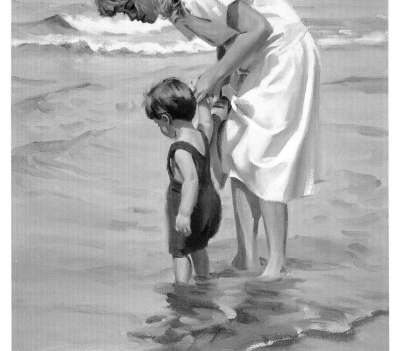

10 With most areas nearing completion, you want to work more on the water in the foreground. With alternating strokes and variations of values and color, capture the appearance of a small wave washing onto the sand. The little white sparkles in this small splash of water show how dark the white foam should actually be painted. With mostly vertical strokes, finish the mother's legs, careful not to get any values lighter than those areas of her feet facing the sun.

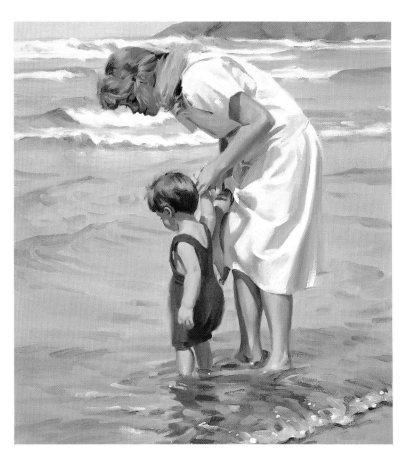

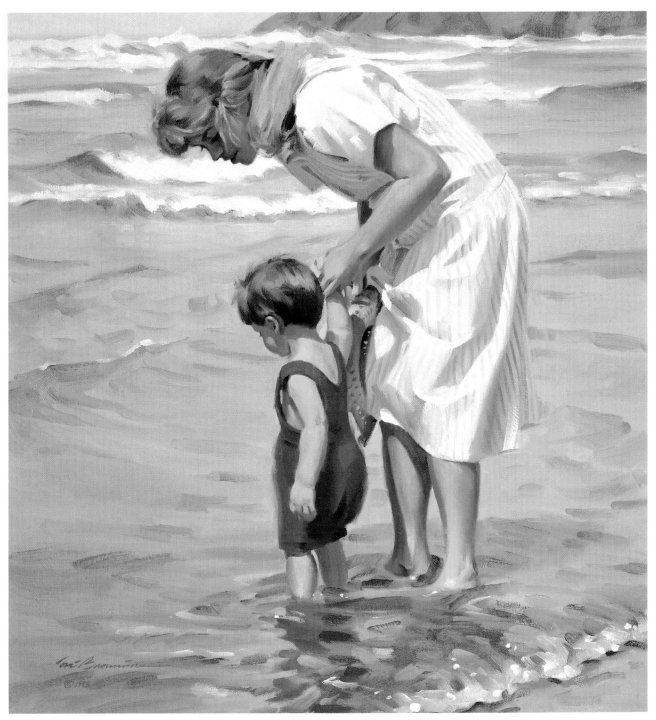

11 THE FINISH

Begin this final stage of the painting by adding some variety to the distant rocks using additional strokes of paint over the water and waves to give them more texture and interest. Lighten up the sky just a bit to keep it from being too cool and too similar to the water by using a warm mixture of Cadmium Yellow and White (this mixture blended nicely into the existing paint that was still wet).

Add in small stripes to the mother's dress. Pink was used here simply because it matched the pink bow in her hair. Paint in a few strokes to the straw hat in the mother's hand to make it more obvious. After making a few drawing corrections in the mother's face, set down your brushes for the last time. Another artist might have wanted to take things a lot further, but if you were to continue on, you would probably end up with a painting that appeared overworked. If you're ever unsatisfied with a painting at this point, it's best to start over and make different decisions from the beginning. After all, making those decisions is where the challenge and fun lies in painting.

TOM BROWNING
"First Impressions"
Oil on canvas, 24" × 22" (60cm × 55cm)

Look for Unusual Light

WATCH FOR THE WAY LIGHT FALLS ON THINGS AROUND YOU

For Roberta Carter Clark, the way the light falls on something can be the sole reason for making a painting. While she was teaching a workshop once, she noticed Molly, the lifeguard, watching the children at the pool. Molly's fair skin actually shone in the strong sunlight, and the dark pines behind her intensi-fied this glow. But it was the unusual blue sunglasses and the shadow pattern they cast upon her bright cheek that made Clark want to paint her. Luckily, one of Clark's students happened to have a camera ready and snapped Molly's picture for Clark to paint later.

ROBERTA CARTER CLARK
"Molly in Blue Glasses"
Watercolor

Roberta Carter Clark floated the Cobalt Blue of the glasses into the shadows on the face and, to emphasize this color even more strongly, she repeated it in the bathing suit and the trees. Clark kept the edges razor sharp where she wanted you to look, and the other edges diffused, making those on the face appear even more crisp. There are tiny touches of white gouache in Molly's necklace and the rim of the glasses on the far side.

LIGHT GIVES IMPORTANCE TO THE MOMENT

Light can change the mood, shape and importance of everyday people and things. Ben Watson III considers light his creative partner. In the painting *Beyond Our Dreams*, it was the light that brought his attention to just how important a moment it was. It turned an ordinary conversation into a mental image that branded itself into his memory for a few weeks before he could actually paint it.

BEN WATSON III
"Beyond Our Dreams"
Watercolor, 21"×28" (53cm×70cm)

Ben Watson III painted broad washes over the door using spatter and handprints to create textures. He then used controlled drybrush to render detail to the wood, door hinge and knob. A combination of colors and values shapes the figure. To finish, Watson went back with lighter drybrush for the hair and the details of the face where the light was strongest.

Designing Your Paintings With Light

No doubt you have heard from a painting instructor or read in an art book that you should "simplify" your painting. It is certainly good advice, but the real trick is how to do it!

AN APPROACH TO SIMPLIFYING

There's an easy way to start learning how to simplify your paintings. Wait for a sunny day. Then grab your easel and head for a suitable painting spot—one that's not too complicated or too simple. It will help, at least for the first attempt, if the subject matter is light in value. White objects are particularly good because they make it easy to see the patterns of light and shade.

See Shapes, Not Things

Position yourself where your view of the subject provides a clear pattern of sunlit surfaces and shaded areas. Now you can begin the process of simplifying your paintings by seeing shapes, not things. Instead of taking the approach of seeing a collection of individual objects—a house, a car, another house, two trees, a picket fence and a partridge in a pear tree—squint your eyes and see only two shapes. Shape One is everything in sunlight. Shape Two is everything in shadow. You have now simplified numerous objects into two identifiable shapes.

Proceed with caution, for if you revert to old habits and draw each object, rather than two shapes, you will have negated the very essence of your new approach. Follow the edge of light and shade. The result will be a rather

SKIP LAWRENCE *"Inner Harbor"* Watercolor, 20"×26" (50cm×65cm)

Painted one warm winter day at the harbor in Baltimore, this painting celebrates light and shade as the figures enjoy the warm winter light.

strange-looking pattern of abstract shapes that should be generous in size. Try to touch each edge of the paper.

Paint the Shade

Now that you are freed from having to paint a myriad of separate objects, you can execute a more spontaneous expression of your feelings. Begin with the idea that what is in light will be left as white paper. This leaves you with only one shape to paint—the shape of shade. Paint the shape as an abstract pattern; don't be overly influenced by

local color. Begin at one end of the shape and paint to the other. One approach is to first wet the entire area of this shape and drop in colors. Take this opportunity to experiment.

GIVE UP OLD HABITS

Like any complicated endeavor, understanding the big concepts is your avenue to success. To succeed in painting, students need to change their concepts and forsake old habits. Stop thinking about brushes, pigments and paper, and think about shape and color.

How to Design With Light

Sunlight is powerful stuff. It can make a black roof appear white and white objects look black. By seeking patterns of light and shade we are freed from the object-by-object routine. Because of the single light source, the sun, there is most often a rhythmical connected pattern of both light and shade. By moving slowly around a potential subject and observing the shapes created by the light and shade you can find the pattern that is most interesting.

Your relative position to the object and the light source changes not only the patterns but also the effect. Sunlight hitting on the back of your head creates small pieces of shadow on the subject, leaving much of the paper white. Sun in your face offers a backlit subject making large dark shapes with rim lighting. Side lighting makes for balanced amounts of light and shade with horizontal cast shadows. This is most traditional and requires considering how balanced you want the amounts of light and shade to be. Generally it is not good to have equal amounts.

The same ideas apply when working in the studio, from still life or figures, using artificial light. But be careful! Multiple light sources make it difficult to see patterns clearly.

Backlighting a subject makes a large connected shape of shade with rim lighting. It unifies so many shapes into generous patterns.

Front lighting produces disconnected spots of dark (shade). When read as a whole and placed against a larger shape, these spots of dark express light and describe objects beautifully.

Side lighting makes alternating shapes of light and dark. This lighting can be a bore without careful consideration of the amounts and size of light and shade. Position yourself where the light outweighs the shade or vice versa.

Art by Skip Lawrence

Number and Placement of Shapes

The number of objects in a scene has an effect on the outcome. One isolated barn, silhouetted against a flat sky, doesn't provide the chance to connect shapes of shade that makes for more interesting patterns. On the other hand, an attempt to see and connect the pattern of five hundred people crossing a busy city street is more aggravating than instructional. Select a moderate number of objects that vary in size and create interesting connections.

Too Many
Too many isolated shapes drive viewers crazy as they frantically try to organize disjointed shapes.

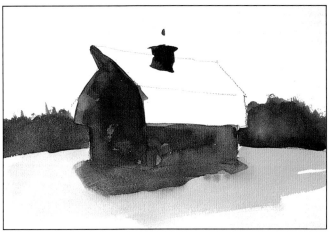

Too Few
Too few shapes lack visual interest.

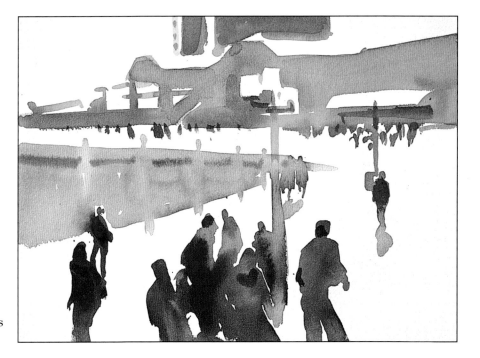

Just Right
A balance of number and placement makes for visually exciting compositions.

Build Patterns by Overlapping

A single row of shapes running horizontally across the paper makes a simple silhouette. But too much simplicity can be boring! To avoid this problem, look for subjects where the shapes are more interesting, and keep in mind the effect of overlapping objects. By including shapes from the foreground, middle ground and background when designing the large patterns of your art, you will find two major improvements: the edges will be more varied and the dynamics of depth will appear.

Art by Skip Lawrence

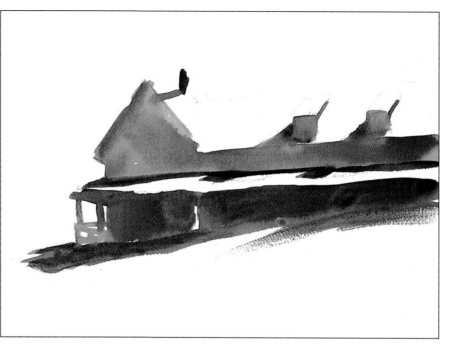

Depth Is Lacking
One silhouetted shape looks like a stage set lacking depth, intrigue and interlocking edges.

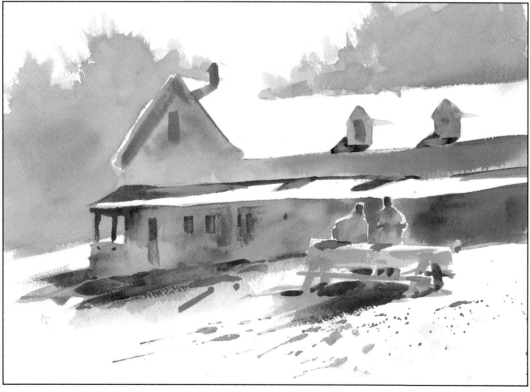

Depth Is Created by Overlapping Shapes
The viewer is invited to move in and out of the painting as well as across the picture plane. The shape is more dynamic because the eye moves from one object to another in a rhythmical progression from foreground to background.

Build Patterns by Connection

Whether its called connections, linkage, lost and found edges, or bridges, it's a term used to describe joining a portion of one edge of a shape to another. It is these connections of edges that make passages and patterns which allow our eyes to move gracefully through a well-composed piece of art. The alternative is a stop-and-go, herky-jerky trip through the barricades of hard edges. Don't let your joy of creativity, enthusiasm and kinetic sensation be stifled in the name of neatness. Don't treat your art as if you are working in a coloring book. Go ahead. Cross the line. All great artists have—why shouldn't you?

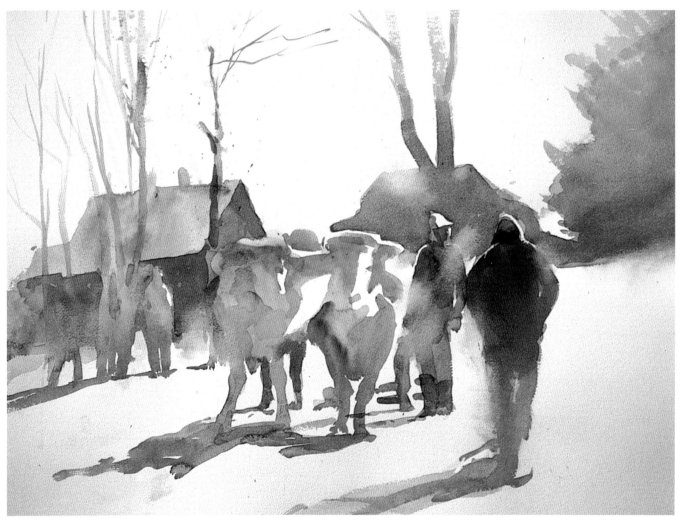

Connect Edges
In this painting of figures, cows and barns, the objects, whether foreground, middle ground or background, are unified as a single shape. Notice how many edges are completely melted together without any loss of content.

Art by Skip Lawrence

Use Light to Express Emotion: Two Approaches

Study the two versions of the painting *Keeper's Place* on this and the next page. The first version represents a traditional handling of the subject. Though it is an accurate depiction of shapes, values and color, it is an impersonal painting, one that does not share ideas and feelings. It is perceived not as coming from the hand of a thoughtful, emotionally involved artist, but rather from someone detailing a list of things seen on vacation. Of the five senses, only sight is called on to make decisions. All that is required of the artist is the ability to draw accurately and match colors.

The second version of *Keeper's Place* is about light. See how the sun has been moved behind the subject to create a more unified pattern of the entire scene. Notice how the linked figures, trees, building and rocks form a continuous flowing pattern of shade. The expression of light is more obvious when unified in its placement and generous in size, rather than broken into small spots where light haphazardly hits the sides of isolated objects. Patterns of shade have been unified for the same reason as light. You need to be able to see shade, not buildings, trees and figures. By unifying their patterns, you're free to paint the shape of shade in a variety of colors and intensities that express your personal feelings of warmth and excitement for the subject.

1 KEEPER'S PLACE II

It is essential to establish your approach and identify your goal from the beginning. With this in mind, begin the drawing by outlining the shape of shade, ignoring the shape of objects. Notice that the line that describes the shape of shade includes many separate objects as it moves from house to rock to figure.

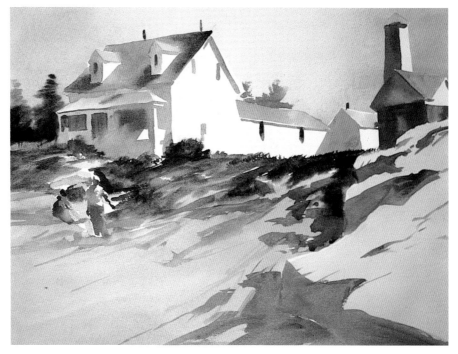

Keeper's Place I
This version is done in a traditional realistic way. Though it is accurate in shape, value and color, it lacks poetry, personal style and evidence of interpretation.

SKIP LAWRENCE
"Keeper's Place I"
Watercolor, 20"×26"
(50cm×65cm)

Never forget that, though light is tantamount to your composition, it must never relegate color to a secondary role. Notice the color differences in the two versions of *Keeper's Place*. Color selection in the traditional painting is based on what your eye simply sees. In the other, there are color choices based on what you feel and understand about the subject. Don't paint what you see, paint the excitement you feel for the subject. And if the excitement is not there, find another subject.

Color is the most expressive element in the artist's vocabulary. To relegate color to a secondary role is to communicate with half a vocabulary.

2 Color temperature, color intensity and color changes are all important here. Keep the value contrasts to a minimum to avoid fracturing the unity of the big shape. Work from one end of the shape to the other to avoid unwanted edges where wet paint is applied over dry. Another approach is to wet the entire shape with either a light value wash of color or just water and proceed by charging in sequential colors.

3 After completing and evaluating the entire shadow shape and while it remains damp, put in color intensity and color temperature changes. Put the most intense color contrasts where you want to draw attention. Here's where you can introduce minor value changes. Remember the word minor! More paintings are ruined by adding darks than by any other element.

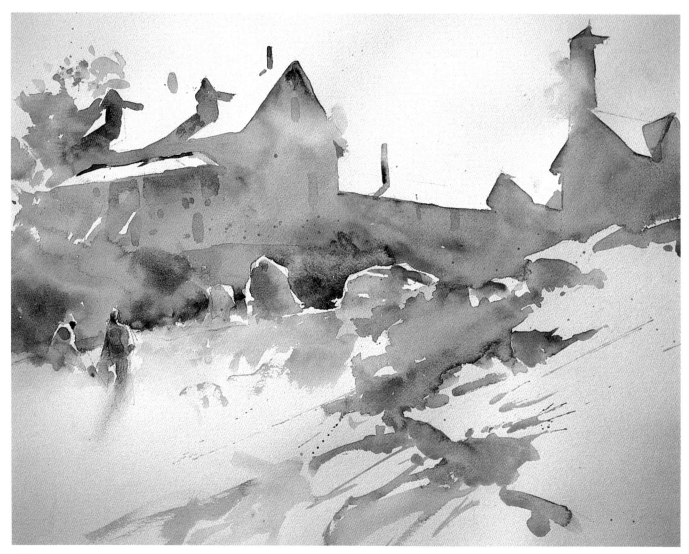

4 Keep your finishing touches subtle. Any additions that challenge the overall pattern should be left out. Look at edges rather than interiors to add interest and change. A little cooler behind the rocks, brighter at the edge of the roof, an indication of grass here and there is all that is necessary to complete this job.

SKIP LAWRENCE
"Keeper's Place II"
Watercolor, 20" × 26" (50cm × 65cm)

REMEMBER

- To simplify your paintings, paint the shapes of light and shade.
- It is important to position yourself to the subject at the spot where the light and shade make the most interesting shapes.
- The number and placement of shapes is compositionally important.
- Overlapping is the simplest and most effective way of creating space.
- Joining small shapes makes large patterns.
- Take time to verbalize vague notions into concrete ideas.
- Select the most appropriate elements to express ideas and emotions.

See the Pattern of Shade

Seeing the shape of shade is not as easy as it sounds. Several hurdles must be cleared before patterns of shade can be accurately observed and used when designing your painting.

DISENGAGE THE BRAIN

Though not something you should do to excess, "turning off" your brain is helpful when the objective is to observe clearly. The brain has too many opinions as to what you should see and often overrides what your eyes actually see. A student once was carefully painting blue sky around the shape of a backlit white house. Because of the backlighting, the white house was not lighter than the sky but darker than the sky. When asked if he could see this, he responded, "It's white." Though the lighting conditions made the house appear as dark against light, his brain still perceived it as white. Never let your brain block your eye!

DISREGARD LOCAL COLOR

The second hurdle is to disregard local color and surfaces that absorb light, making it difficult to observe light. The perception of color is directly related to the reflection of light waves. Dark surfaces absorb much more light than do light surfaces, which makes it hard to see them as light-stuck. Porous surfaces, such as roof shingles, grass, foliage and sweaters, also absorb light and can look dark in direct sunlight. On the other hand, shiny surfaces can fool you because they reflect values from other surfaces. Water often appears dark when reflecting shaded surfaces even though it is in direct light.

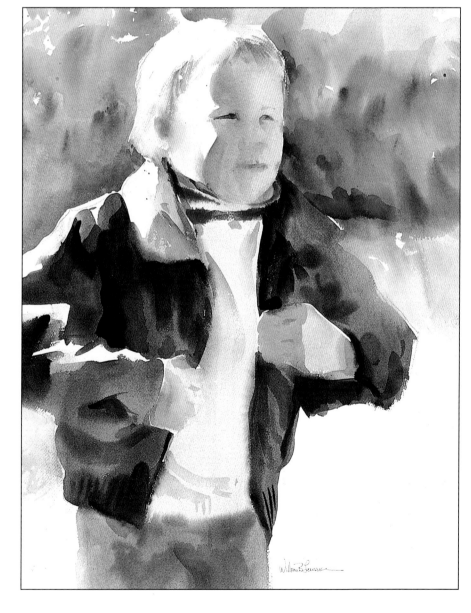

The most dramatic and instructive approach to the idea of "designing with light" is to begin by exaggerating the contrast of light and shade.

Design With Shade
This painting demonstrates how to design with the shape of shade. Notice that the shapes used do not represent the shape of head, coat, shirt and pants, but only that portion of these objects that is in shadow. The portions in sunlight remain white.

SKIP LAWRENCE
"Joshua"
Watercolor,
20"×26" (50cm×65cm)

DON'T BE FOOLED

Here are some ways to keep from being fooled by absorbent and reflective surfaces. Identify the source of light, be it the sun or a lamp, and remember that anything perpendicular to it is in light. Look for cast shadows. Any surface that has cast shadows on it is in light. Dark surfaces are difficult to read. Look for their angle to the source of light and for cast shadows. A shadow identifies the direction of the light and whether the surface is in light. There will be times when the white of a house in shadow is a darker value than the black of its roof in sunlight.

Photograph of Portland Head Lighthouse

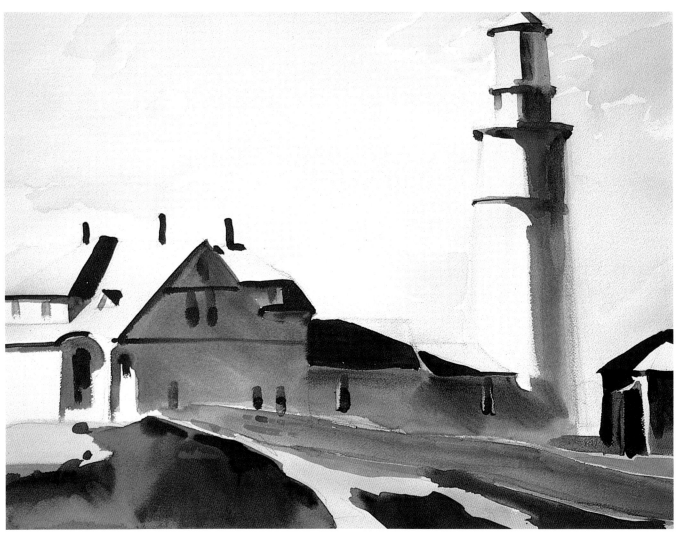

To create the large shape of this painting, mass together the entire shape of shadow. Compare the two shapes and you will see that the shape of shade is more interesting than the shape of the lighthouse. Notice that part of the orange roof is missing. The missing section is unnecessary and its omission creates a more beautiful shape.

SKIP LAWRENCE
"Portland Head Light"
Watercolor, 20"×26" (50cm×65cm)

ENDLESS POSSIBILITIES

The beauty of seeing the patterns of light and shade is the compositional possibilities provided. There will be times when you elect to ignore the effect of light on a color—times when it is compositionally advantageous to paint the sunlit roof black and times when it is best to paint the black roof light. The point is, you do have the choice.

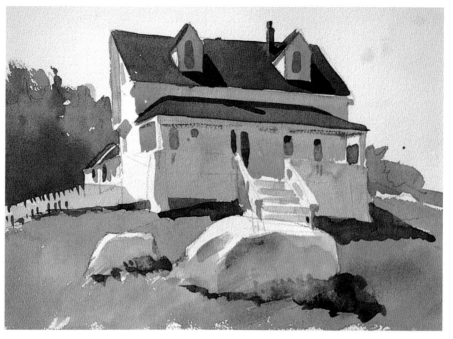

Version One

There are occasions when the white of a house in shadow might appear darker than a black roof in sunlight. In this painting, see how the use of local color (black roof, white house) does not look accurate to the eye, though it certainly makes sense to the brain.

Armed with the idea of designing with light and shade, there are infinite possibilities as to the relationship of one to the other.

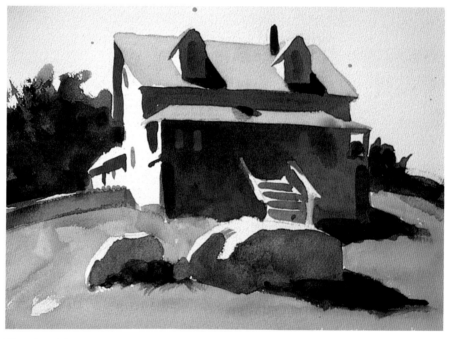

Version Two

In the second version there is visual accuracy. The black roof does appear lighter in value than the shadow portion of the white house. Take the time to make these observations for yourself, and they will be more believable to you and provide options when you design.

Art by Skip Lawrence

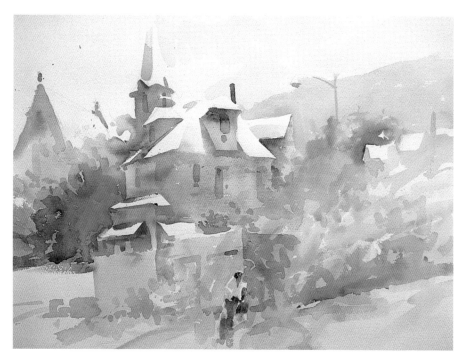

SKIP LAWRENCE
"Cumberland, MD"
Watercolor, 20" × 26" (50cm × 65cm)

Only the planes that are in shadow are painted. By keeping the values relatively close, you'll be able to change color freely, keeping emphasis on expressiveness.

Look at these wonderful patterns of sunlight and shade. The low morning direction of light created a beautiful network of shapes. The color choices were arbitrarily applied to create the freshness of the day.

SKIP LAWRENCE
"Beaufort, NC"
Watercolor, 20" × 26" (50cm × 65cm)

Composing With Spotlight and Floodlight

SKIP LAWRENCE
"Light at Pemaquid Point"
Watercolor, 20″×26″
(50cm×65cm)

This book gives you an approach to designing paintings using lighted shapes and shaded shapes. Everyone who paints representationally relies on light. Without light you can't see—not the subject or even the paper on which you work. But there is a large difference between painting what you see and painting the many forms of light you see. Light has color and differing intensities; it can be direct or reflected; it can define local color, obscure local color and alter local color.

Wait for a foggy day, and you'll see for yourself the transformation of colors, values and textures into a symphony of softness. Subtlety is the key word on these days.

Becoming acutely aware of specific lighting conditions can make you a better painter. Before you begin to paint, take time to observe the color, intensity and other qualities of light. Ask yourself whether it's warm or cool, clear or hazy, direct (like a spotlight) or filtered (like a floodlight). Being sensitive to light will not only help with your paint-

ing, but will turn on a whole new world of color. Every color in nature is reflected onto every other color. A clear blue sky is evident not only in the sky but throughout the entire landscape. And then, when you're asked, "Do you see those colors?" you can raise your eyebrows, look the questioner in the eyes and respond, "Don't you?"

SPOTLIGHT

Too often, less experienced painters use the spotlight approach when painting on location. Each object is defined by its light side, shadow side and cast shadow. There is much to-do concerning where the sun is and how it describes form. The problem with this approach is the resulting painting places too much emphasis on isolated objects and not enough on the overall patterns that are created by a single light source, the sun. You have to remember the sun is ninety-three million miles away. It illuminates the entire atmosphere of half the earth and is not directed, like a theater spotlight, at individual objects.

We perceive objects as spotlighted on days when the atmosphere is crystal clear. On these days everything seems sharply focused and hard edges abound. Mountains ten miles away, a house fifty yards away and the person you're talking to all have the same crisp clear edge. It is essential on these days that you find the bridges, those edges of nearly the same value, color or texture that will lock these shapes into the painting. Cast shadows often provide the connections you need. Look for cast shadows that link darks together.

The sky, water and lighted side of the boats are kept close enough in value to make all three areas read as a unified expression of sunlight. The shape of shade is the right size, shape and value to convey the effects of clear light.

SKIP LAWRENCE
"Florida Reflections"
Watercolor, 22"×30"
(55cm×75cm)

When the sun is bright and the atmosphere clear, value contrasts are strong and edges are crisp. Such beautiful patterns of light and shade!

SKIP LAWRENCE
"Ft. Myers, FL"
Watercolor, 20"×26"
(50cm×65cm)

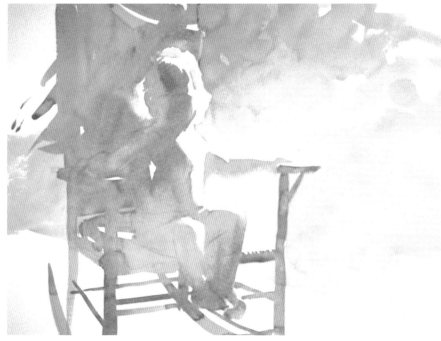

It is not always necessary to express strong sunlight with extreme value contrast. Think about those times when sunlight is so bright as to be blinding, when light obscures edges rather than defining edges. The quality of light in this painting seems much brighter than the light in the paintings on the previous page.

SKIP LAWRENCE
"Carly on the Farmhouse Porch"
Watercolor, 20″ × 26″
(50cm × 65cm)

VALUE CONTRASTS WITH SPOTLIGHT

You may have heard from time to time that stronger light makes darker darks. Though that sounds correct and logical, it's not necessarily so. Some paintings that best express strong light don't generally use extreme value contrasts, but very close values. Remember that on an extremely bright day, the light that creates seemingly black shadows is reflecting off everything and back into the shaded areas. This lightens the value of the shadows and reduces the value contrast. The exception to this is when you're in a canyon of vertical planes where reflection is minimal, such as midtown Manhattan, or when the light source is very weak, such as a candle or 40-watt lightbulb. In these cases the darks are very dark, because the light is not strong enough to reflect.

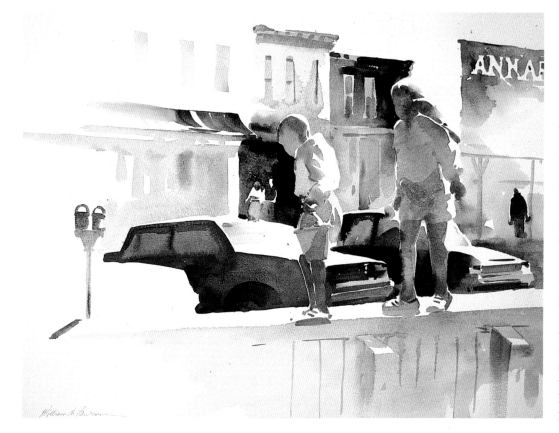

SKIP LAWRENCE
"Tight-Wall Walking in Annapolis, MD"
Watercolor, 20″ × 26″
(50cm × 65cm)

This is one of those times when light can be expressed by painting only shade. The reflective surfaces of automobiles, the absorbing surfaces of the kids' clothing, walls and buildings are all surfaces in direct sunlight and left as white paper. All color changes are made in the shadow shapes. The strong value contrasts and the hard edges combine to express strong light.

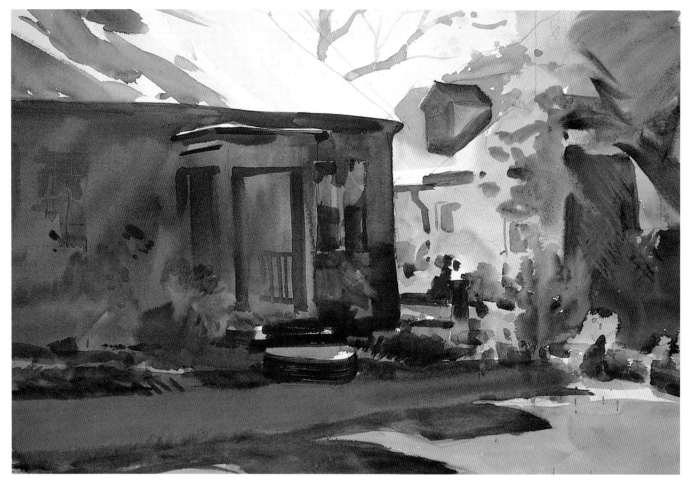

These observations are not absolutes, for you will certainly find other exceptions. Be a student of light. Cleanse your mind of preconceptions and look at light and the effects it creates. Light is not always warm, and shade is not always cool. Look, be sensitive, and be amazed by what you observe.

SKIP LAWRENCE
"Kinston House"
Watercolor, 20″ × 26″ (50cm × 65cm)

Color is an equal and essential partner when portraying light. It is not enough to squint your eyes and see only values. You must look into the shadows and identify the colors that are there. Don't look for formulas or shortcuts to tell you what colors shadows should be or always are. Look for the warm colors in the shade and the cools in the sunlight. It takes some practice to allow your eyes to see shapes, values and colors. Take the time!

FLOODLIGHT

The quality of light from a floodlight differs from that of a spotlight in significant ways. The floodlight comes more from an overhead direction, produces softer edges and reduces value contrast. Think of light as something created by the sun illuminating the earth's atmosphere, filtered and falling gently to the earth's surface, like snow. Except for those few hours during dawn and dusk when the sun is very low and the sides of objects are directly lighted, this perception is both useful and accurate. The sun is a floodlight that illuminates an entire segment of the earth—not a spotlight that moves from house to tree to figure like the lighting in a stage performance.

By thinking of the sun as a floodlight, you'll benefit from different perceptions of light, which will improve your painting. The first of these perceptions is that floodlights produce a soft-filtered light that softens edges. Where edges are softened, the eye moves gently from shape to shape, color to color. Razor-blade edges, the result of spotlighting, stop the eye's movement, isolating shapes and colors. They give the perception that the objects exist in a vacuum. Some of the worst paintings on earth are hard-edged, high-contrast portraits of houses.

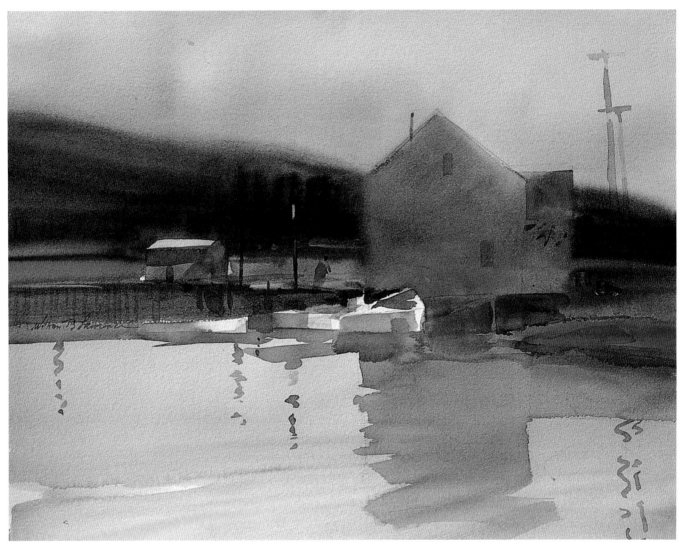

The effects of using a floodlight approach rather than a spotlight are quite significant. Edges are softer, value contrasts are closer, and color takes on a more important role. This painting was done from a photo taken on a sunny day, but the spotlight effect of a sunny day was changed into the floodlight effect of a hazy day. In so doing, subtleties of value, color and texture contrasts become more predominant.

SKIP LAWRENCE
"South Bristol, ME"
Watercolor, 20"×26" (50cm×65cm)
Collection of Alex Powers

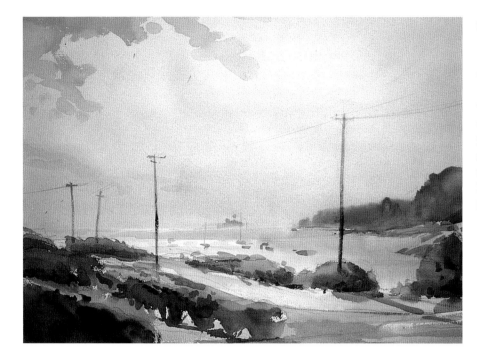

SKIP LAWRENCE
"Long Cover"
Watercolor, 20" × 26"
(50cm × 65cm)

The white, hazy light of August was used to create a floodlight effect for this painting. As an alternative to creating atmospheric images that are the result of moisture, you can obscure distant shapes with light. It's as if you're looking through milky light rather than through water.

VALUE CONTRAST WITH FLOODLIGHT

Floodlighting is a softer filtered light that reduces value contrast. The truth is that all light is filtered. After all, the light of the sun has to travel through two hundred miles of the earth's atmosphere. Artificial lights are not exempt from the effects of the billions and billions of molecules that make up our atmosphere. If you are having difficulty seeing the effects of the atmosphere, imagine you are painting underwater. The earth's atmosphere is nothing more than very thin water, so this approach often makes a difference. An obvious example of the effects of atmosphere and of the floodlighting idea is a foggy day. Fog and the filtered light it creates reduces value contrasts and softens edges.

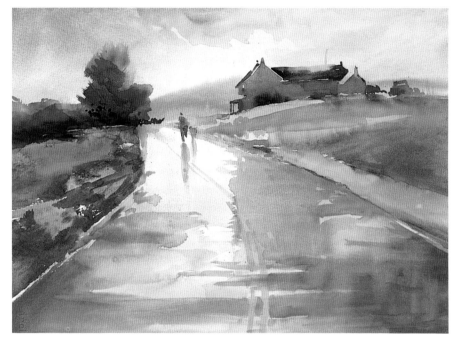

Instead of looking for a perfect, clear sunny day for painting, take advantage of inclement weather. On just such days you will find the beautiful effects of floodlighting. When else will you have the chance to see reflections on a road? Only with such soft-filtered light can you use bilious colors and have them look natural.

SKIP LAWRENCE
"Mountaindale Road"
Watercolor, 20" × 26"
(50cm × 65cm)

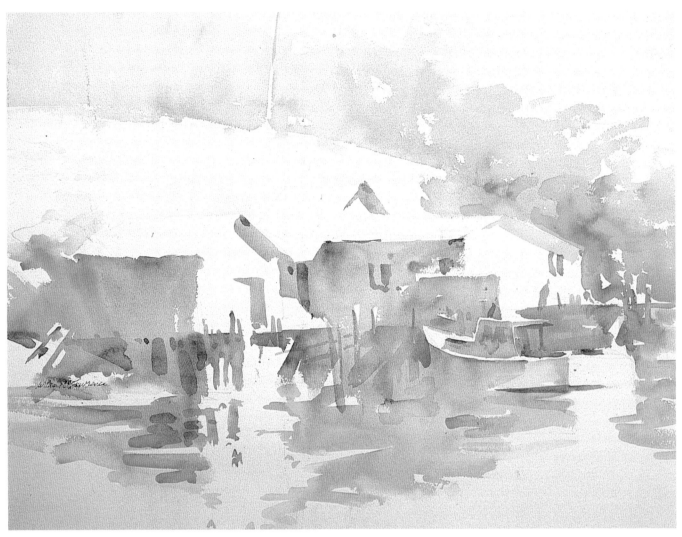

SKIP LAWRENCE
"Lobstermen's Coop"
Watercolor, 20" ×26" (50cm × 65cm)

Now you don't have to paint fog to understand the effect of floodlighting on value contrast. Just remember that no matter how clear the day, you are always seeing everything through veils of illuminated atmosphere. Using this approach you will know that it isn't possible to see the extreme values of white or black. When you reduce value contrasts, your paintings are filled with atmosphere and color plays a much more important role. Even the most subtle of colors suddenly become visible and exciting.

With floodlighting, value contrasts are close. Instead of the value contrasts changing from white to black, think of reducing the contrasts from white to *slightly* darker. The effect of these close value contrasts is a feeling of brilliant light that reflects off everything and keeps even the value of shadows light. Take care to lose edges, which helps to give the impression of soft-filtered light.

LIGHT FROM ABOVE

Another effect of floodlighting, or the idea of the sun illuminating our atmosphere, is that light appears to fall from above and settle on the tops of things. The best way to understand this idea is to think of light as snow. On what surfaces does snow collect? Wherever you know snow would collect is the same surface where light collects. Vertical planes don't hold the snow. The more horizontal the plane the more snow accumulates and the lighter that surface appears. The same is true of light. A lawn, for example, appears not as green grass but rather as a horizontal plane collecting light. The same is true of a black roof, a figure's shoulders or the rail of a boat. Vertical planes, upon which the snow (light) cannot collect, retain more local color and appear darker in value.

Remember that the shadow side of objects does not get darker, but only appears darker due to the contrast of being seen against the light. When there is strong light, what we identify as being shadow is not darker than before the light was turned on, but actually a little lighter. So, don't paint the lighted side of an object lighter and the shadow side darker than local color, but paint the lighted side lighter and the darker side lighter.

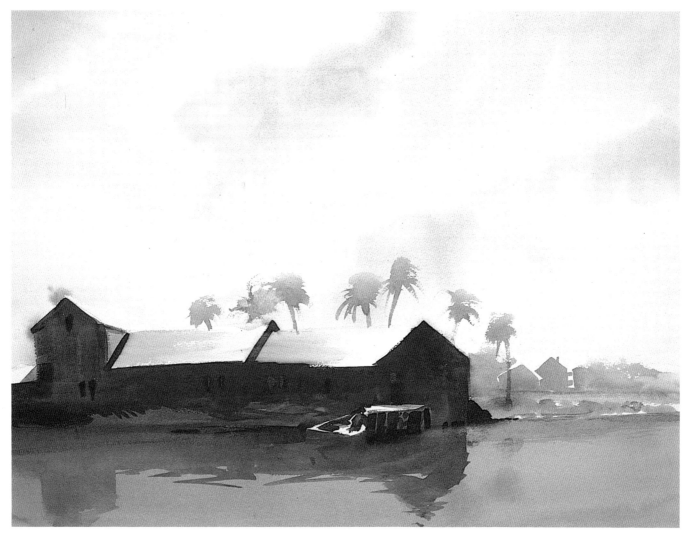

Florida White is about the intensity of light—that intense light that falls from above like snow and obliterates the color of everything upon which it falls. In cases such as these, pay particular attention to how the falling light affects the flat planes it settles upon.

SKIP LAWRENCE
"Florida White"
Watercolor, 20"×26" (50cm×65cm)

Step-by-Step Demonstrations

Paint Light in Crystal and Lace in Watercolor

LIZ DONOVAN

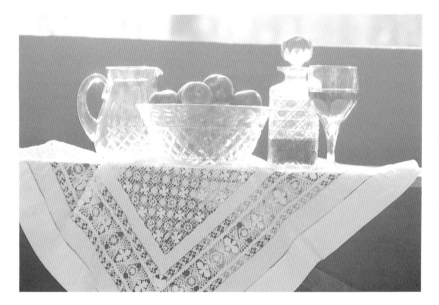

1 ARRANGE YOUR SETUP

Deciding on a specific approach and solving design or lighting problems are enjoyable preliminary steps in the painting process. Though the reference slide of the setup shown here is not good, it gives enough information to proportion the objects and place the light correctly. Liz Donovan arranged this still life in front of a large glass door. Feeling that a dark background would dramatically enhance the impact of this painting, she placed a large black board behind the items in the setup. The daylight flooded in over the top of the board, creating a special sparkle in the crystal glassware. Once you are satisfied with your overall arrangement, take a series of slides at close range.

COLOR PALETTE

- Alizarin Crimson
- Aureolin Yellow
- Cadmium Red
- Cobalt Blue
- Rose Madder Genuine
- Winsor Green
- Winsor Blue

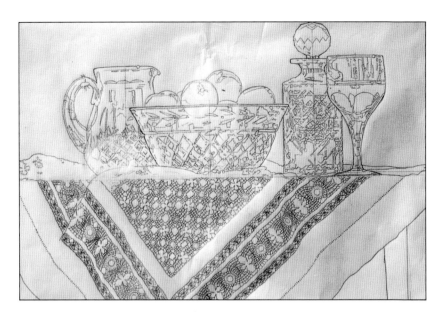

2 CORRECT CAMERA DISTORTION

Choose a slide that clearly represents your view of how the piece should look, and project the image onto Trazon tracing paper, a drafting paper with a blue grid used to correct camera distortion and perspective. Donovan chose to add an extra plum on the left to balance the composition.

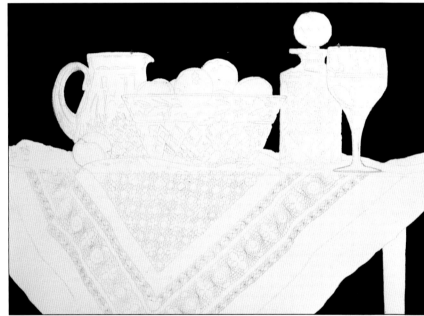

3 TRANSFER CORRECTED DRAWING

Transfer the corrected drawing to 300-lb. (640gm/m²) cold-pressed watercolor paper. Place tape around all four sides for a clean edge. Use graphite transfer paper between the watercolor paper and the original drawing to trace over the image using only the lines you need to help you find your place in the painting. Now paint the background with a mixture of Alizarin Crimson and Winsor Green. The rich, dark value serves as a great contrast for the gleaming glass.

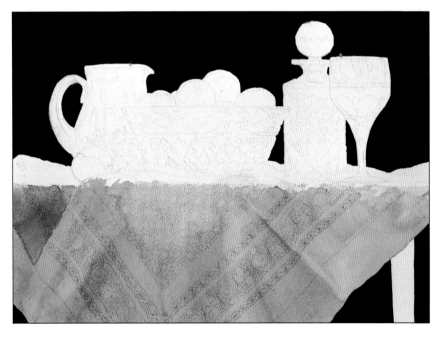

4 START THE CLOTH

Paint a light Cobalt Blue wash over the front of the lace cloth to create a cool underlayer, and let it dry completely. Paint over it with a darker wash of Cobalt Blue, Rose Madder Genuine and Aureolin Yellow. Describe the flow of the cloth and develop areas of interest by varying the color intensity.

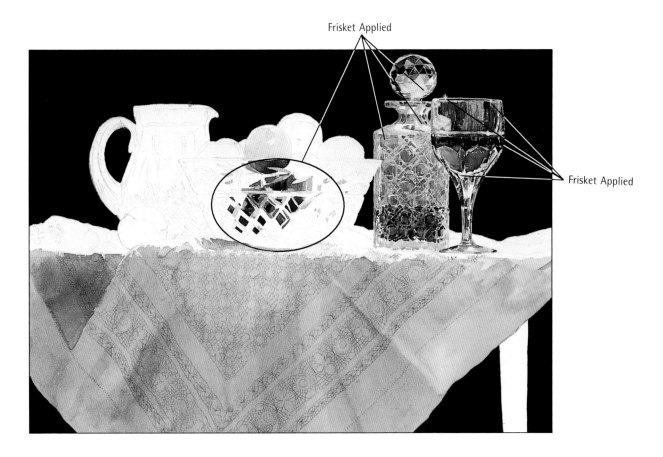

Frisket Applied

Frisket Applied

5 CRYSTAL AND PLUMS

Capturing the true look of sparkling, faceted crystal comes from maintaining absolutely pure highlights and concentrating on the images reflected in the glass surfaces. Apply liquid frisket to the white areas to preserve highlights. Shown here, the frisket appears as a gray color (see the whites ultimately preserved on page 102). Use a thinner type of frisket, such as Pebeo drawing gum. It can be applied in fine lines when

necessary. Let it dry, then with a mixture of Alizarin Crimson and Winsor Blue paint in some of the darkest values of the plums showing through the crystal, the wine in the decanter and the wine in the wine glass. This gives you the darkest value against which to judge other values. Now you can paint the other abstract shapes of the crystal facets by layering more intense versions of the colors found in the lace cloth. Let dry.

Remove frisket. Paint the frosty blue tint of the plums. Use warm red tones for the front plum placing it in front of the cooler, darker ones behind it. Using the same reds, yellows and blues retains the overall color harmony. Keeping the stem sharp and light-struck helps it come forward. A halo of light separates the plums from the background.

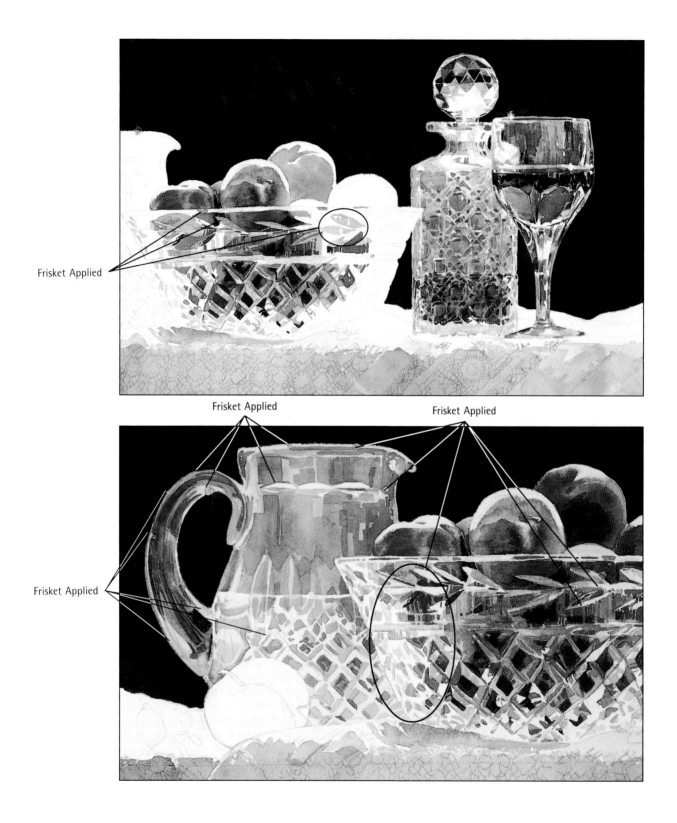

Frisket Applied

Frisket Applied

Frisket Applied

Frisket Applied

Frisket Removed Frisket Removed

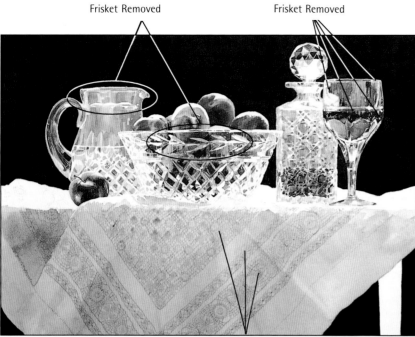

Frisket Applied

6 BEGIN LACE PATTERN
Apply frisket to the open latticework pattern of the cloth and let it dry completely.

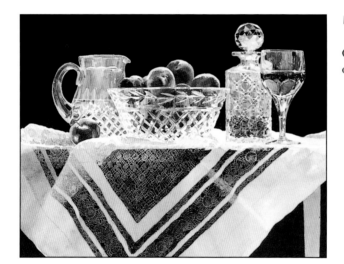

7 APPLY DARKER WASHES
Apply darker washes of various Alizarin Crimson and Winsor Green mixtures to the openwork areas of the cloth.

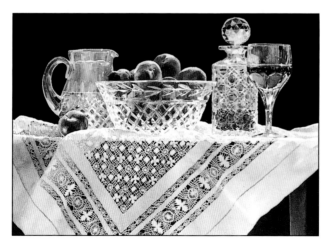

8 REMOVE FRISKET, SHADE
When the frisket is removed, the lace looks more natural than if you had painted each tiny hole individually. Add shading for more depth and interest.

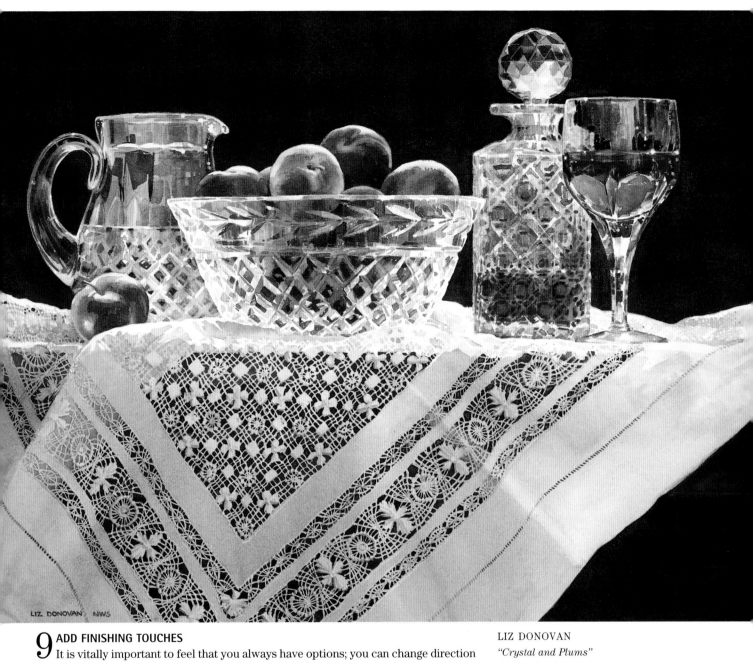

9 ADD FINISHING TOUCHES

It is vitally important to feel that you always have options; you can change direction when necessary. Donovan decided at this late stage that the table leg on the right side of the painting was superfluous and detracted from the composition. She also felt the painting needed some strong additional color, so she added accents of pure Cadmium Red along with other finishing touches.

LIZ DONOVAN
"Crystal and Plums"
Watercolor, 20¾" × 28¾" (52cm × 72cm)

Paint the Sparkling Effect of Top Light in Oil

PAUL STRISIK

Photo

This reference photo of the subject is not very interesting. There is, however, lots of interesting material scattered about the boatyard. In such cases, feel free to use whatever you wish to convey a more interesting impression.

1 WASHING IN WITH DIRECT COLORS
Wash in a general composition with approximate colors. To capture the effect of top light, add sparkling light on the roof of the red shack. The trees form a dark silhouette against a bright greenish blue sky.

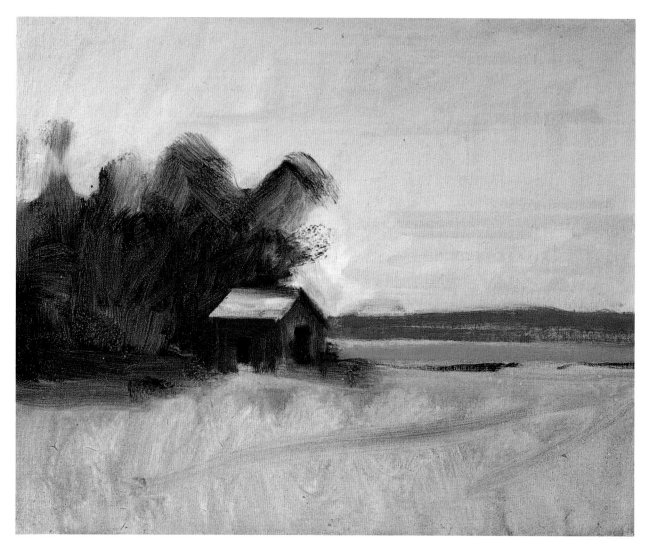

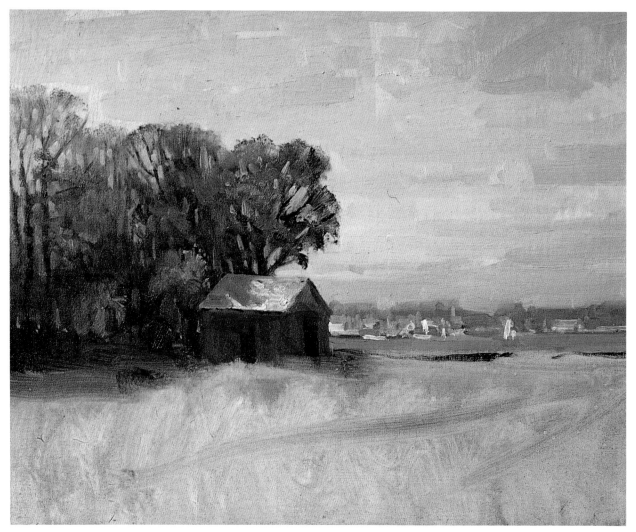

2 DEVELOPING TREES AND SKY

The sky is broken up with light lavender clouds highlighted with touches of very light orange plus white. Develop and shape the trees by using sky holes, and add touches of green without losing the silhouette.

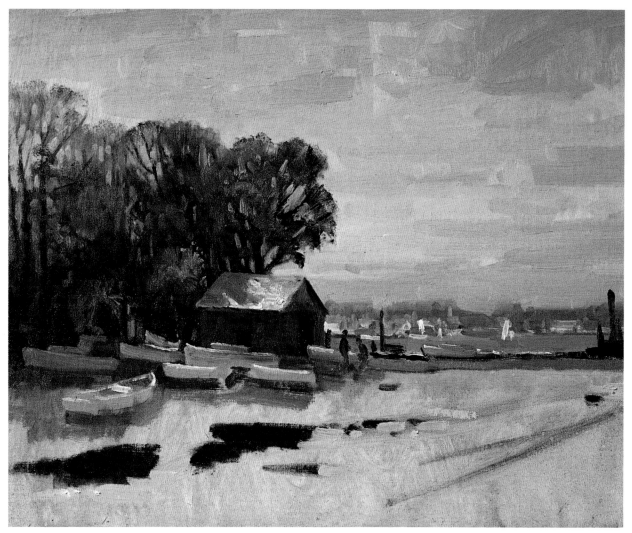

3 ADDING INTEREST

Even though the distant water cannot be seen in the reference photo, it adds great interest. Various boats and rain puddles are placed about. Paint the foreground with Yellow Ochre, touches of Terra Rosa and White.

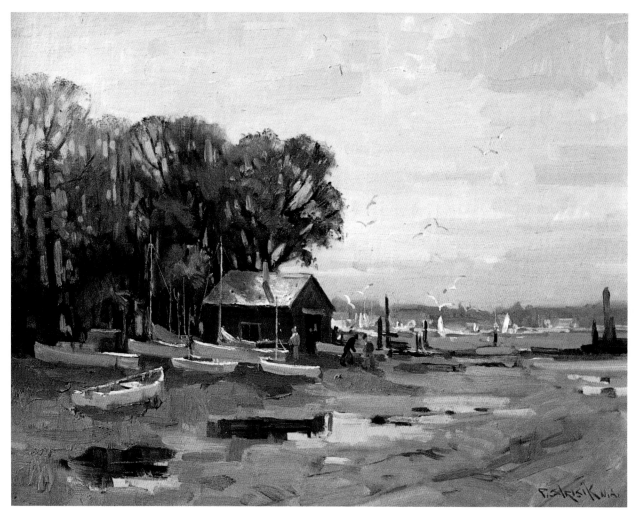

4 ADDING ACCENTS IN THE STUDIO
Freshen up the colors a bit by adding accents where needed. The light effect is one of an almost overhead sun, so all vertical planes are in shadow and all top planes receive a strong top light.

PAUL STRISIK
"Essex Boatyard"
Oil, 16" × 20" (40cm × 50cm)

Paint Refracted Light in Watercolor

LIZ DONOVAN

Distortions from refracted light occur in objects seen through glass. The water in this glass exaggerates this effect so stems and leaves at the water line appear disjointed.

COLOR PALETTE

- Alizarin Crimson
- Aureolin Yellow
- Cobalt Blue
- Rose Madder Genuine
- Ruby Red (LeFranc & Bourgeois Linel)
- Viridian
- Winsor Green

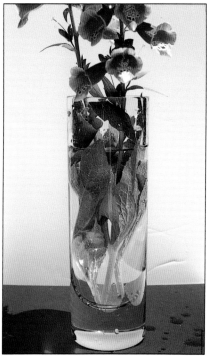

Reference Photo

1 PAINT BACKGROUND COLOR, SAVE HIGHLIGHTS

Pick a modified yellow color for the background to complement the purple foxglove. Save a few highlights so they won't be lost when the dark leaf values are applied. Bring the same background wash into the vase and paint another coat of background color over the tabletop.

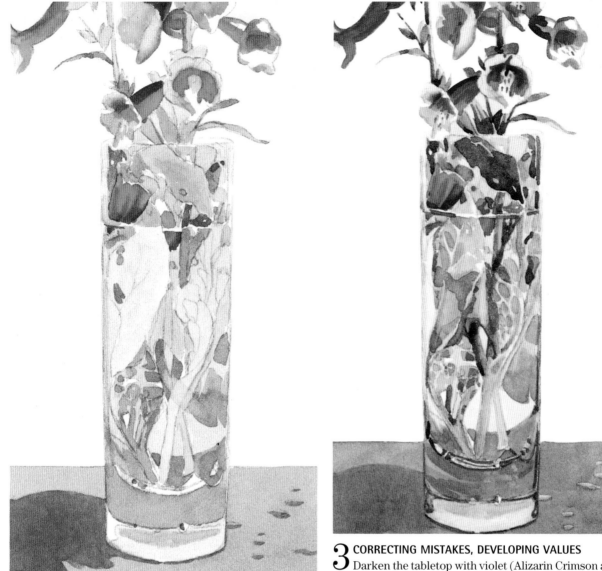

2 PAINT THE CAST SHADOW AND FIRST WASHES

Paint the cast shadow and water spills using a purple version of Rose Madder Genuine, Cobalt Blue and Aureolin Yellow. Some of the purple color is brought into the vase. Leaves and flowers are underpainted with pale greens and roses. Liz Donovan chose Ruby Red, a LeFranc & Bourgeois Linel watercolor, for the foxglove. Mix this with a little Viridian for the shadow areas of the flowers. Because of the purity of flower colors, it's difficult to get just the right color by mixing, so you may want to keep a collection of small tubes of reds and purples for flowers.

3 CORRECTING MISTAKES, DEVELOPING VALUES

Darken the tabletop with violet (Alizarin Crimson and Cobalt Blue). The yellow underpainting shows and grays or modifies the violet. The reflection in the bottom of the vase must be a version of this color, so add a yellow glaze. Accidental discoveries keep the painting process exciting. For example, though the tabletop and reflection in the bottom of the vase should have been treated alike, the bit of purple showing through the bottom of the glass works well, so it isn't wrong.

Obtain bright saturated leaf colors by mixing Winsor Green and Aureolin Yellow. Be careful, these colors can overpower a painting. For subtle shades of green try Viridian and Aureolin Yellow with Rose Madder Genuine to modify or Alizarin Crimson to darken. Paint the green segments between the leaves first, leaving the yellow background as veins. When dry, blend with a damp brush. Remember the cylindrical shape of stems as they turn from light to shadow to reflected light. Use a large round brush (no. 10). Change color and value on the paper as you paint rather than mixing separately on your palette.

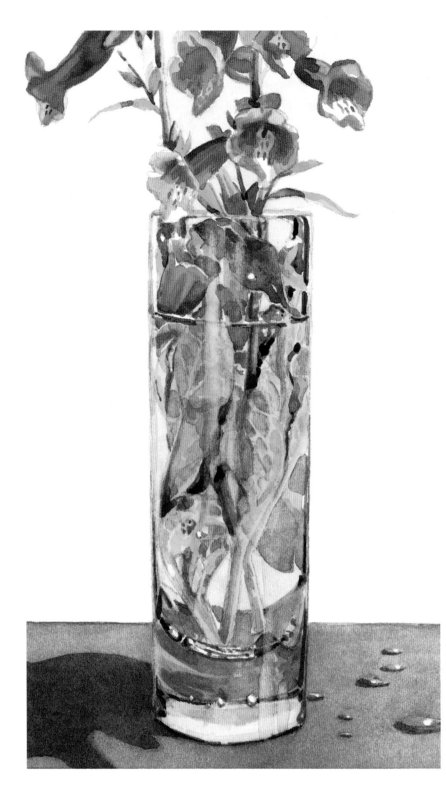

4 ADD DARKS FOR CONTRAST AND REMOVE FRISKET

The spaces between stems and leaves where the background shows through look too light. This is an optical illusion that happens when dark areas surround a light area. (In landscape painting these would be called sky holes and are always painted darker than the sky to compensate.) Make these areas a shade darker using another coat of the background color. Remove the frisket and bring some darker values into the leaves in water and the glass vase. A wet brush, drawn down the side of the glass, adds a highlight. Darken the cast shadow and scrape highlights in the water drops on the tabletop.

BLOTTING

Keep a tissue on hand to quickly blot any passages that appear too dark. But use it only when absolutely necessary. Lots of fresh color is lost by the tentative blotting of an unsure hand. Usually it's better to let the value dry and then see how you like it. You can always wet it again and then blot or lift with a brush if it's not right.

Find Sunlit Subjects Right at Home

MARILYN SIMANDLE

Light and Shadow

There is nothing extraordinary here, yet more than enough to inspire a painting. This house sparkles in the sunlight, which creates intriguing shadow patterns. It also has that wonderful flowering shrub out front.

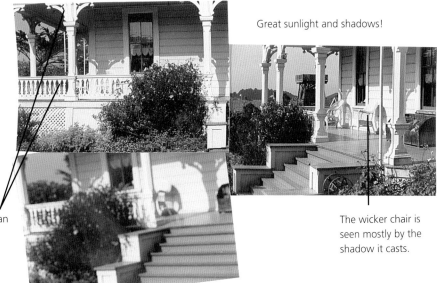

Great sunlight and shadows!

Ornate Victorian details.

The wicker chair is seen mostly by the shadow it casts.

1 PLAN YOUR COMPOSITION

Take lots of liberties with your composition, rearranging elements and planning shadow patterns with thumbnail sketches. They're the quickest way to decide on a viewpoint, what to include, what to omit, how to deal with shadows, background and so on. The final sketch includes sunlight flooding in from the upper left, creating shadows that slant down to the right, and results in an interesting triangular shadow shape at the top right. The complex, colorful point of interest will be in the sunlit area to the left. Brilliant, simple whites and low-key shadow areas will contrast at right. Planning at this stage pays off in a big way later on.

2 LAY THE FOUNDATION

A fairly careful drawing on your watercolor sheet affords a first look at the full-sized composition. This is your best opportunity to adjust sizes, proportions, etc.

3 PUNCH UP THE POINT OF INTEREST

Let's begin right at the point of interest. Lay in bright color and work out from there. The large shadow mass at upper right establishes the dark value.

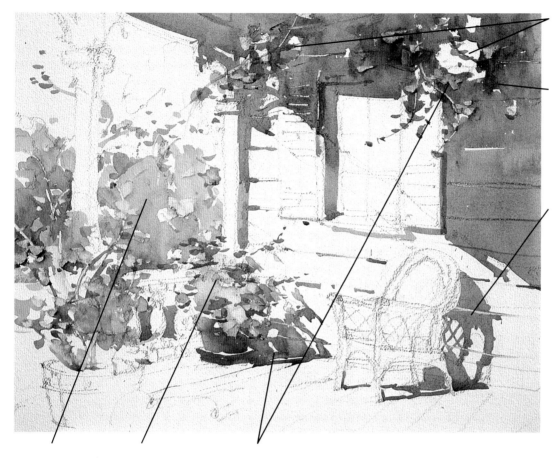

Leave ample white for sparkle.

Build shadow shape with Manganese Blue, Raw Sienna and Permanent Rose. Keep varying it— greenish around hanging plants, warmer as you move along.

The chair is defined by its shadows.

Big shapes first; Permanent Rose plus Manganese Blue dropped in wet. Scratch in lines.

Lay in Manganese Blue with a touch of Permanent Rose for a soft lavender hue.

Mix Manganese Blue, Raw Sienna and a little Permanent Rose to create muted greens. Lay that in wet so it blends with shadow hue.

4 BUILD VALUE AND COLOR

It's time to start glazing in deeper values, brighter colors, highlights and accents.

Build flower shadows with Cobalt Blue, then move that color around the painting.

Begin painting negative background space around flowers.

Use Cobalt Blue and Permanent Rose for shutters. Use that hue elsewhere too!

Suggest tree reflections with Burnt Sienna and Antwerp Blue.

Define calligraphic stem and vine details with a rigger brush or palette knife.

Carve in shadows with Raw Sienna and Antwerp Blue, adding depth to foliage and creating negative spaces between balustrades.

Burnt Sienna shadowed with Antwerp Blue creates the rounded pot.

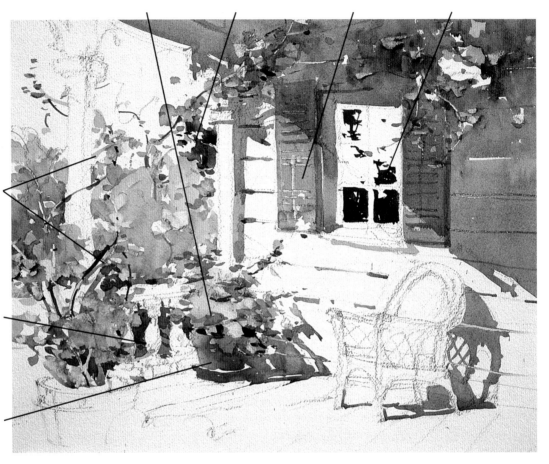

5 LAY IN THE BACKGROUND

In this close-up, see how the painting takes on depth and dimension as you paint in the negative areas of the background.

Lighten green for airy distance by adding Raw Sienna and Cadmium Yellow to the mixture.

Define the post with background color.

Cool the green with Cobalt Blue for distance.

Begin darkest green (Antwerp Blue with Raw Sienna) here and work left.

Work dark greens around and into pinks. Poke "holes" in the flower mass as you do.

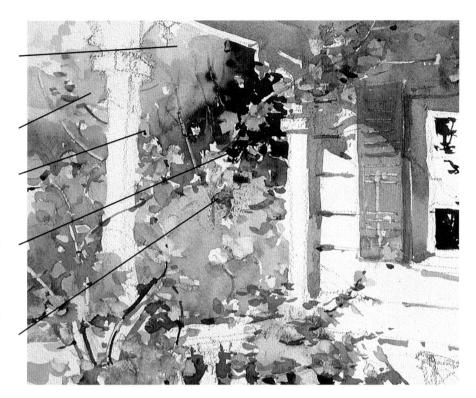

Add more stems and vines for interest.

Dark accents make background recede, move post forward.

Continue glazing to enrich colors and build texture.

Continue to enrich flower and foliage hues.

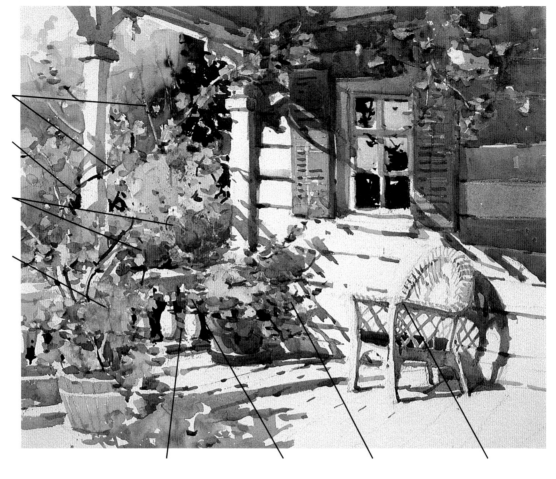

See how shadows shape the balustrades.

Create shadows using my familiar gray mix: Raw Sienna, Permanent Rose and Manganese Blue.

Add bright accents of Cadmium Orange.

Add minimal wicker details with warm grays.

7 ADD FINISHING TOUCHES

Step back and look at your painting for a day or so, separating yourself from your involvement with creating it. Return later with a fresh viewpoint to adjust shadow values and add a few more spots of color. As you can see, exciting subject matter can be found around your own house. Don't waste your precious painting time looking for the perfect subject. Take the commonplace and make it exceptional through your painting!

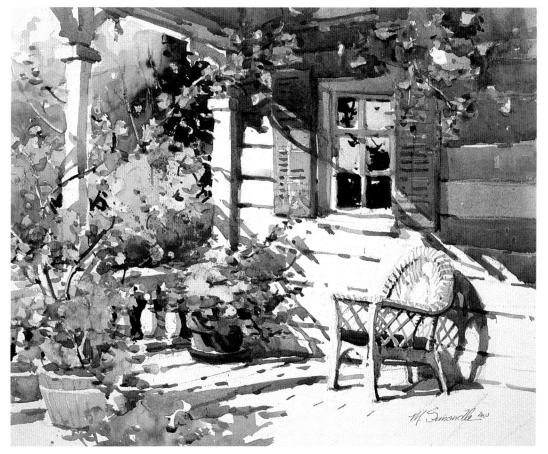

MARILYN SIMANDLE
"Porch Shadows"
Watercolor, 14" × 18" (35cm × 45cm)

Making the Ordinary Sparkle in Pastel

SALLY STRAND

Light is the essence of Sally Strand's art—ordinary people and situations made extraordinary with brilliant light and shadows. Her subjects reflect life near her Southern California home, people in casual poses on patios, beaches and bowling greens. With the bold value contrasts from a strong overhead sun, these unremarkable people become intriguing arrangements of color, shape and value.

Strand begins with photos and sketches of likely subjects. Because she is capturing candid moments, gesture is a primary consideration.

As she develops the painting, she builds up the lights and darks. She doesn't use white for her brightest highlights; instead, she combines strokes of her lightest colors, which look like white because of the contrast with darker surrounding values.

For darks she may start with a layer of charcoal strokes, then she enlivens the shadows with colored strokes on top of the black. For less intense darks, she uses a dark-colored underpainting or she simply layers strokes of various dark colors.

Details are important only insofar as they establish the situation. Rarely are any details rendered with fine precision, except for the accents of bright highlight that enliven the composition.

1 Artist Sally Strand uses Arches 300-lb. (640gsm) cold-pressed watercolor paper stapled to a piece of plywood on which she draws and then fixes her basic outline in charcoal. Strand says, "I do a watercolor underpainting with a 3-inch (8cm) housepainting brush. It is not very involved. I think in terms of large value areas and color temperatures—cools to go under the warm wall and a warm shadow on the figures and foreground."

2 Here Strand is establishing the major values. She is aware of her limitations, that only a certain degree of light can be attained with pastels, so she is constantly judging everything against the lightest light spot. She does not want to lose the center of interest by getting too light overall, so she adjusts the value of the light background down to allow her lightest lights to stand out. Fixative is applied.

3 Here Strand is adjusting shapes against each other, going into more detail, but still trying to maintain the big pattern. As she increases contrast she tries to keep the light pattern and the dark pattern separate, but working together. She uses lots of layering in the shadows, allowing some of the watercolor wash to show through, as in the shirt of the man where the warm wash is coming through the cool blues and violets on top. She sprays with fixative.

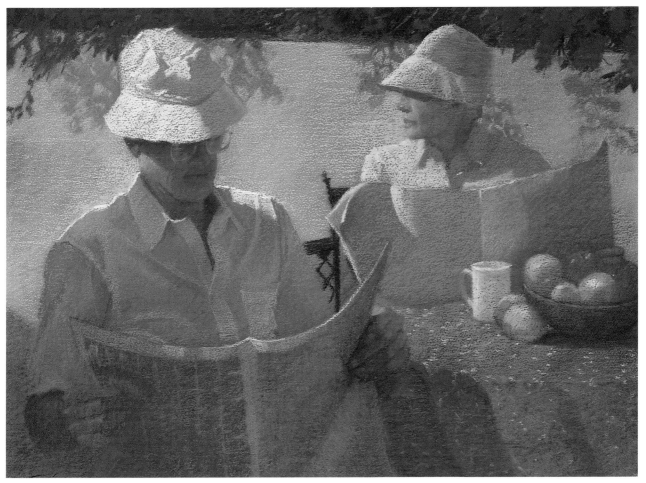

4 Strand adds more details, always careful to step back and look at the painting as a whole. She sprays fixative one last time before adding the highlights. The lights on the man's hat are to be the lightest lights so Strand is careful to keep all other highlights secondary. This constant balancing of value and color is what makes the light in Strand's paintings so believable.

SALLY STRAND
"Morning News"
Pastel and watercolor, 20"×27"
(50cm×68cm)

More From Sally Strand

SALLY STRAND
"Sun-Dried"
Pastel and watercolor
28"×40½" (70cm×101cm)

Simple Patterns

Strand solves the problems of painting complicated images of light and motion by reducing everything to simple patterns of value. Color is important, the soft pinks and blues giving a gentle feel to the painting, but value is the key, especially the bright highlights that convince us of the sunlight.

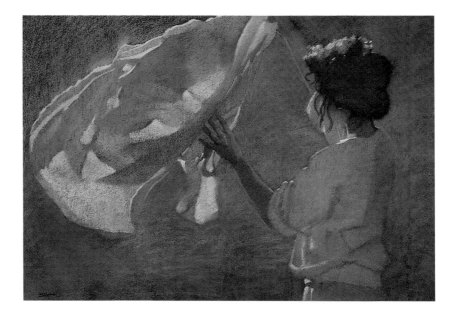

Glowing Whites

One of the characteristics of Strand's paintings is the use of glowing whites. The highlights are never actually painted with pure white, but are done in very light colors—blues and violets here.

SALLY STRAND
"Men in White"
Pastel and watercolor
28"×42½" (70cm×106cm)

Paint Moonlight on Snow in Watercolor

ZOLTAN SZABO

The most effective way to get the beautiful softness of moonlight on snow is to make use of watercolor's wonderful ability to lift off the paper after it has dried. But there is one crucial element in planning this kind of painting that cannot be ignored. You must know your pigments well and choose only nonstaining colors for the area you will be lifting. Don't wet the paper. When the paper is wet, even non-staining colors seep in and are hard to lift.

COLOR PALETTE

These four colors are nonstaining and will lift to pure white to carve out the shadows:

- Manganese Blue: good for the greenish color of moonlight mixed with the other colors.
- Aureolin Yellow: tones down the Manganese Blue.
- Cobalt Violet: this neutralizes the Manganese Blue and Aureolin Yellow mixtures.
- French Ultramarine Blue: can be lifted to near white for areas that need a darker shadow.

Use these three staining colors for rich darks:

- Sepia: the darkest color, used with restraint and rarely, if ever, alone.
- Halo or Winsor Green: use with Sepia for a cooler neutral dark.
- Burnt Sienna: use with Sepia or other colors for a warm sparkle in the darks.

Manganese Blue	Aureolin Yellow	Cobalt Violet	Sepia	Winsor Green	Burnt Sienna	French Ultramarine Blue

1 SHADOW WASH AND DARKS

Mix lots of Manganese Blue and Cobalt Violet with a little Aureolin Yellow. Test the color on a small piece of watercolor paper. Make sure it is dark enough. It may be necessary to add a little French Ultramarine Blue. This means that you will not be able to lift all the way to a paper white, but the stronger dark will mean greater contrast. Be sure to mix enough color.

To wash in shadow tone, tilt the board slightly toward you (an inch [3cm] elevation will do). With a 1½-inch (4cm) to 2-inch (5cm) soft brush, starting about one-third down from the top, quickly cover the dry paper with the mixture you just made. Carry your brushstrokes all the way through from side to side. The color will get lighter as it gets closer to you, toward the bottom of the page. Add more color if necessary, starting again at the top of the page and following through with your brushstrokes.

While your wash is drying, begin the background darks at the top of the page. Using French Ultramarine Blue and Burnt Sienna with a bristle brush, cover the background with vertical strokes of color. As you paint, vary the color from warmer to cooler. Add a bit of Winsor Green in some places. Watch for vertical shapes appearing in the darker values because of the bristles of your brush. They may resemble trees and other foliage.

Go back and add more tree shapes, making use of the "accidental" shapes your brush has made. For these vertical dark strokes you can use the edge of your wide bristle brush or a smaller brush. Use Sepia mixed alternately with Burnt Sienna and Winsor Green. Bring some of the strokes down to reach into the middle ground. When the darks are almost dry, brush some Aureolin Yellow across the central area where the light will be coming from.

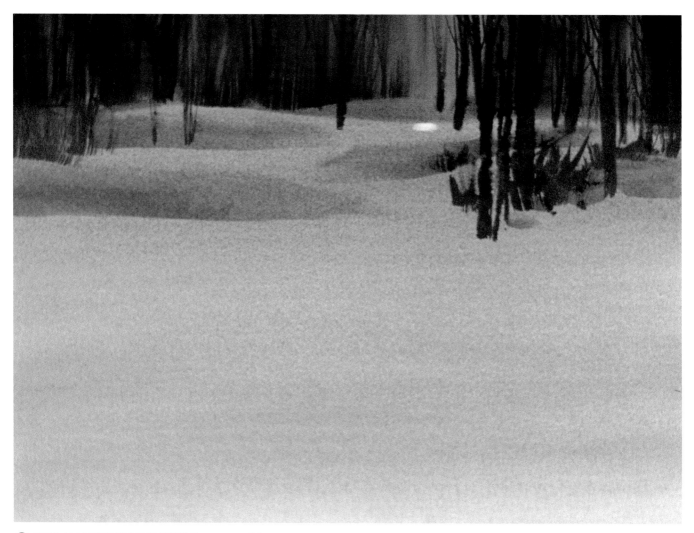

2 COMPLEMENTARY DARK SHAPES

Before you go any further, make sure your colors will lift off. Some papers don't respond well to lifting. With clean water and a small brush, lift out a small amount from an area you know you will need to lift. If the color doesn't lift to your satisfaction, you may need to start over on a better paper.

Add dark positive tree shapes in the background both for composition and to describe the subject more fully. Use Sepia with either Burnt Sienna or Winsor Green.

Make sure some of the tree shapes overlap the Manganese wash. Rich, deep value is very important. This area also acts as a complement to the cool blue shadow color, so be sure to keep it on the warm side. Add some variety to the tree shapes with a small rigger, giving the illusion of light and dark branches. Make sure the two sides balance but aren't equal in volume and design.

When the background is dry, create the humps of snow using a mixture of French Ultramarine Blue and Aureolin Yellow.

Make quick strokes with a ¾-inch (2cm) brush at the base of the trees. Lose the top edge immediately by a quick stroke with a clean, thirsty brush. Add drama with more variation in the ground level using the self-blending slant bristle brush. Apply color only to the long hair tip and keep only clean water on the short bristles. Then as you make your brushstroke, it will blend its own edge toward the short hair end.

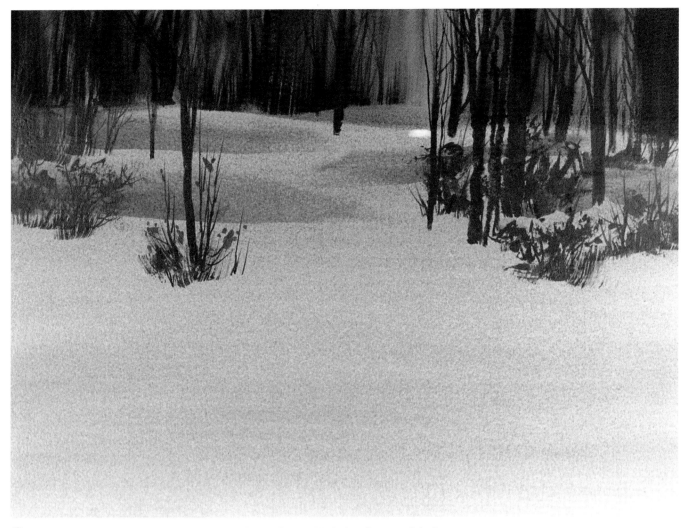

3 MORE DARKS IN MIDDLE GROUND

Using the 1½-inch (4cm) slant brush, make more dark middle-ground shapes. This will break up the monotony and will create a cause for the effect we are going to make: shadows on the snow. Again, use the dark Sepia varied from warmer to cooler when mixed with Burnt Sienna or Winsor Green. To establish the clusters of dark mass, you need to use lots of paint and very little water.

Drop in a few individual twigs or branches with a small rigger to make the clusters interesting. Use a little bit of pure Burnt Sienna for highlights for what appear to be warm, illuminated leaves.

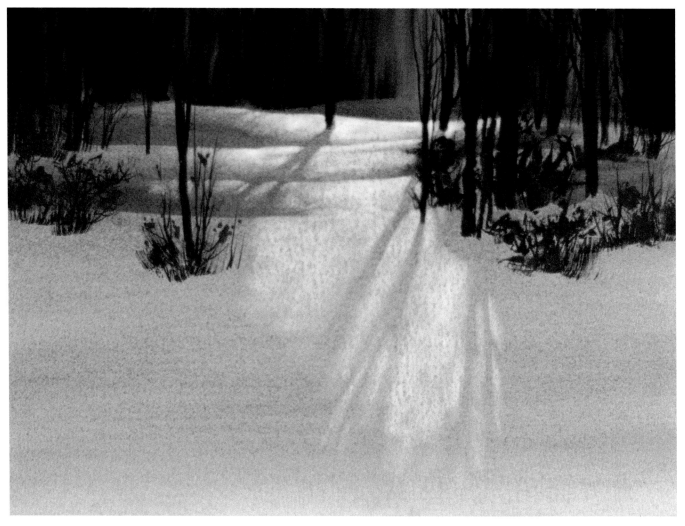

4 LIFT TO WHITE FOR MOONLIGHT

In this step you will be lifting the color to create the glow of moonlight. At the same time, the dark shapes you leave will create shadows that will flow from the trees and ground trees. Remember, you are not lifting the shadows, you are lifting the light. Work slowly, continually checking that your shadows are extending logically from the dark foliage. Protect the integrity of the shadows by making the white patches islands—the shadows should be continuous.

For your lifting technique, use a few different sized old bristle brushes that have not been used for oil paint—the more worn-out the better—and a box of paper tissues.

Using a fair amount of clean water, scrub a small area you want to lift and blot immediately with a tissue. Keep changing tissues so the color doesn't get pressed back into the paper. Don't rub the paper with the tissues.

To lift a small area to very white, hold a small brush firmly and use lots of water, blotting with clean tissues. As soon as the pigment is loose, blot it. For larger areas that do not need to be as white, use a larger brush pressed less firmly and scrub more quickly. Switch brushes to vary the amount of color lifted and to vary the edges.

If you accidentally touch a middle-ground dark shape with your scrubbing brush, blot it off right away before it has a chance to contaminate the shadow color. You can reapply the dark after the area is dry. It is better to lift too little than too much.

Start at the rim where the light is brightest. Use lots of water in your brush. Scrub horizontally with a small motion. Continually stop and look to get your bearings for the placement of shadows. The shadow edges should vary from sharp to blurry—sharp where the object is close to the surface, blurry where it's far from the surface. Shadows taper toward the light source. Elevation will mean a value change.

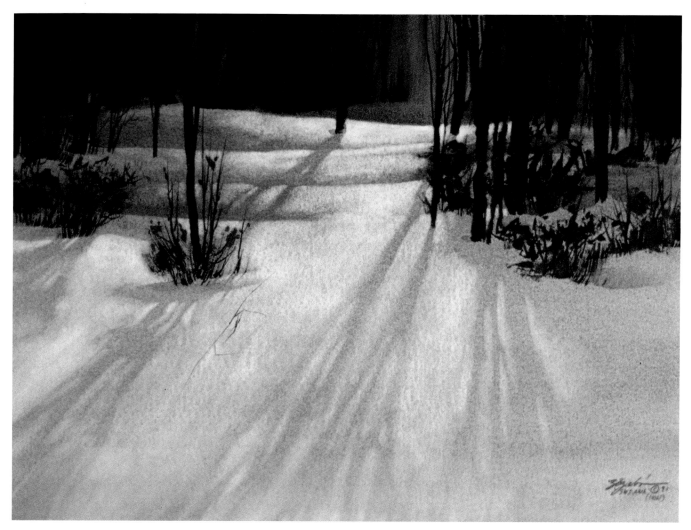

5 FINISH

Complete the lifting of the light, continuing step 4's principles to vary the edges of the shadows and the brightness of the light. Remember to consider your distance from the light source, the shadow-casting object's distance from the surface, changes in ground elevation—in other words, obey all natural laws about light and shadow.

As you get farther from the light source, reduce the amount of lift. Be sure that the light is echoed on the trees. The slower you expand the glow, the gentler the light will appear—and the more dramatic. As you get close to the foreground, you can use a bigger brush and move it in the direction of the light to leave longer, less distinct shadows.

This technique is more effective than painting shadows because a shadow does not have a texture of its own but only takes on the texture of the surface it falls on. In this case, the tooth of the paper, which is quite visible in the lifted areas, represents the sparkle on the snow.

When the painting is dry you can make any necessary corrections. Mix some of the original blue color to extend the shadows of the trees to the bottom of the page. Your brushstrokes should go in the opposite direction, from bottom to top. Touch up any Sepia areas that were lifted. If you wish, you can add some positive shadows to the small weed in the foreground.

ZOLTAN SZABO
"Silver Moon"
Watercolor, 15"×20" (38cm×50cm)

INDEX